Great
IRISH
ARTISTS

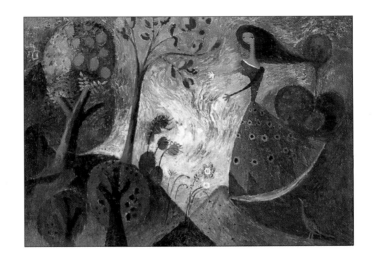

DEDICATION

For Doreen, with love

Previous page: *Bonfire Lady* (1943)
Colin Middleton
AIB Art Collection, Dublin

Facing page: *A Race in Hy Brazil* (1937)
Jack B. Yeats
AIB Art Collection, Dublin

Editor *Fleur Robertson*
Design concept *Heather Blagdon*
Designer *Stuart Perry*
Jacket design *Justina Leitão*
Production *Ruth Arthur, Karen Staff, Neil Randles*
Director of Production *Gerald Hughes*

Published in Ireland by
Gill & Macmillan Ltd, Goldenbridge, Dublin 8
with associated companies throughout the world

CLB 4942
© 1997 CLB International, Godalming, Surrey

ISBN 0 7171 2610 2

All rights reserved. No part of this publication may be stored in
a retrieval system, or transmitted in any form or by any means,
electronic etc., without the prior permission of the publishers

Printed in Spain

Great IRISH ARTISTS

FROM LAVERY TO LE BROCQUY

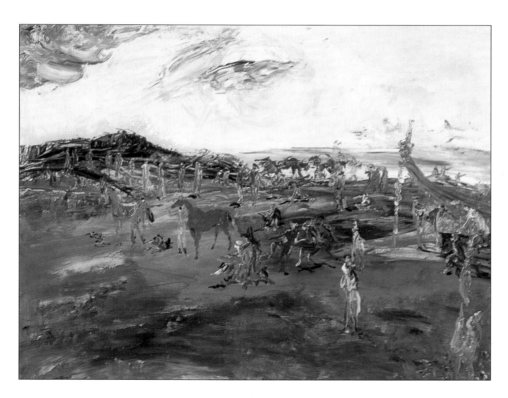

S. B. KENNEDY

Gill & Macmillan

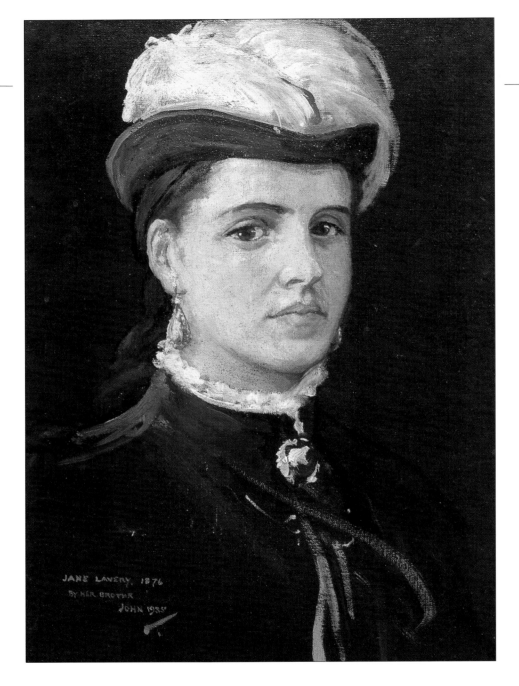

JANE LAVERY, A POSTHUMOUS PORTRAIT (1935)

SIR JOHN LAVERY

PRIVATE COLLECTION

Contents

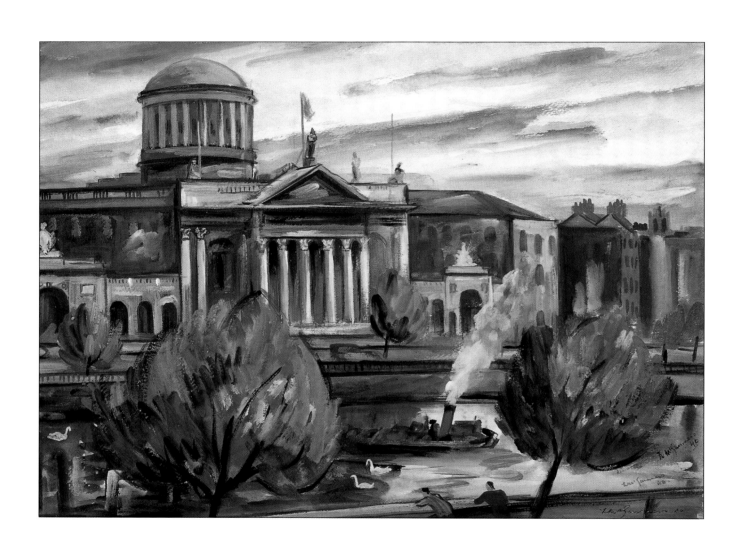

THE FOUR COURTS (1940)
NORAH McGUINNESS
ULSTER MUSEUM, BELFAST

Introduction

The period covered by this book saw many changes in the visual arts both in Ireland and abroad. At the time of Walter Osborne's death in 1903 a stuffy conservatism dominated much, perhaps even most, of Irish painting. French Impressionism – which had already caused such a flurry in France – was as yet unknown. In Ireland, as in other places, there was then a significant lapse of time between the development of a movement such as Impressionism and its adoption among artists, let alone among the general public. But with Osborne and one or two others things had begun to change. By the mid century, and certainly after 1960, such a time-lag had not only disappeared but was rendered inconceivable with advancing communications technology. That which happened, say, in New York one day, happened in Ireland the next. Such was the change in the pace of life as we all become citizens of the often referred to 'global village'.

But there is a price to pay for such instant communications and, perhaps more than anything else, that price has been uniformity everywhere and in almost everything, so that it is now virtually impossible to say that an art work, for example, is typically Irish, or French, or American or whatever. Yet throughout the period in question in this book the idea of a distinct Irish art, something which was never agreed upon, occupied the hearts and minds of many artists, critics and others. Perhaps given the events which shaped the early part of the period – the Literary Revival, the home rule issue, the Easter rising of 1916, the Anglo-Irish war and the establishment of the Irish Free State, the subsequent civil war – it is not surprising that Irish artists should have longed for a distinctly Irish form of expression. That was not to be: in contrast to the literary figures who after 1922 turned their attention inwards upon themselves and the new state, the visual arts looked outwards, increasingly drawing their inspiration from France and the mainstream of Continental Modernism as it was still evolving. It is for this reason, no doubt, that Irish painting largely ignored the upheavals of the revolutionary period which so dominated the literary field. Perhaps it is only now, with the passage of some seventy-five years from the foundation of the modern Irish state, that this divergence of approach can be seen clearly and that the achievement of the Irish painters can be looked at in a dispassionate manner.

The selection of any group of artists to satisfy the criteria of a book such as this, with the unavoidable limitations of space and so on, is invidious; inevitably that selection must, to some extent, reflect the personal preferences and prejudices of the author. In the main the present selection places emphasis upon those who 'made the running', initiating ideas and influences which others followed or developed. Yet even within these parameters many excellent painters have been ignored and, indeed, that which one might term the 'academic tradition', which valiantly persisted in the face of the onslaught of Modernism, has also been largely ignored, as has the strong landscape tradition of the inter-war years, the latter arguably being one of the glories of twentieth-century

Irish art and perhaps the nearest development to a national school of art.

The artists included are discussed in chronological order according to their date of birth. The eldest, John Lavery, Walter Osborne and Roderic O'Conor, were all influenced quite radically by contemporary painting in France in their day. While Lavery spent most of his career in England, he maintained strong Irish connections, and Osborne, of course, settled in Ireland. They were both genre painters as well as distinguished portraitists. O'Conor, on the other hand, settled permanently in France and had little influence in Ireland. W.J. Leech was chiefly a landscapist, although he too produced a number of genre works. He lived for a long period in France before settling in England; although he exhibited in Ireland it was never, beyond his youth, to be his home. Both George Russell (Æ) and Jack B. Yeats were individualists and, apart from Yeats' early years in England, they kept their attention focused solely on Ireland. Russell may be regarded as Ireland's best Symbolist painter and Yeats, rightly, is considered to be the most important painter Ireland has produced this century. Paul Henry and his wife Grace both studied in Paris and, after settling in the West of Ireland, brought an element of Post-Impressionism to bear upon their painting. Paul, more than anyone else, led the way towards what was to become a formidable school of landscape painting, his vision of the West, in particular, being so compelling that even today it is difficult not to see that area other than through his eyes. Orpen, on the other hand, besides a youth spent in Dublin, looked only to London for inspiration, although his experiences as an official war artist in France during the First World War had a profound effect on him. While his subject-matter varied he was without doubt one of the two or three most important portrait painters in England in his day. His pupil, Sean Keating, however, had eyes only for Ireland, for the Aran Islands and the West, but more than anyone Keating tried – alas with only limited success – to define and establish a distinct Irish school of art.

Of a younger generation, that is, those born closer to the turn of the century, many still drew inspiration from France. Mainie Jellett was perhaps Ireland's only 'true' Cubist painter. She had a thorough understanding of the theories of Cubism, unlike many of her contemporaries who merely adopted a technique which made use of cube-like shapes and forms. She also developed a fully abstract art form years in advance of anyone else in Ireland. Like Jellett, Norah McGuinness encountered Cubism at first hand in Paris, but she rejected it as being, for her, too arid and instead adopted a more lyrical style, much influenced by Fauvism, which better suited her temperament. John Luke studied in London but immediately settled in his native Belfast where, like his contemporary Colin Middleton, he spent his whole career. Luke is most remembered for his ability as a draughtsman and for his severely stylized and mannered technique. Middleton, by contrast, was much more experimental and may justifiably be regarded as Ireland's first Surrealist painter. Louis le Brocquy, the youngest of this group of artists, is principally a figure painter, his subject-matter often probing the inner recesses and psychology of human existence. Although he has lived for many years in France, he regularly visits and exhibits in Ireland.

In preparing the text which follows, I have endeavoured to guide the reader towards ways of

looking at and studying the pictures which are illustrated, rather than attempting principally a discussion of the imagery, the place of the work in the artist's *œuvre* and so on. Thus, where it seems appropriate to do so, I have drawn attention to such things as an artist's compositional technique, his or her manipulation of the picture plane, use of form, shape, line, colour, etc., elements which, in the later part of the period in particular, are of vital importance to our understanding of many of the works. Indeed, with the more abstract pictures such things are all one has to find a 'way into' the composition. A discussion of the media the artists employed seems pertinent, therefore, since, above all, pictures are to be looked at, contemplated and enjoyed.

S.B.K.

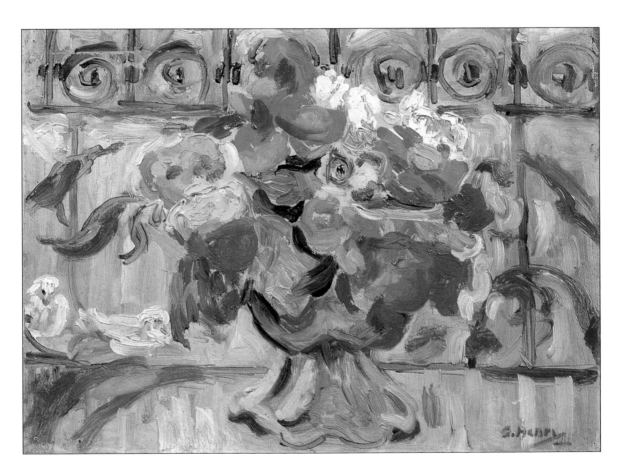

FLOWERS (1911)
GRACE HENRY
AIB ART COLLECTION

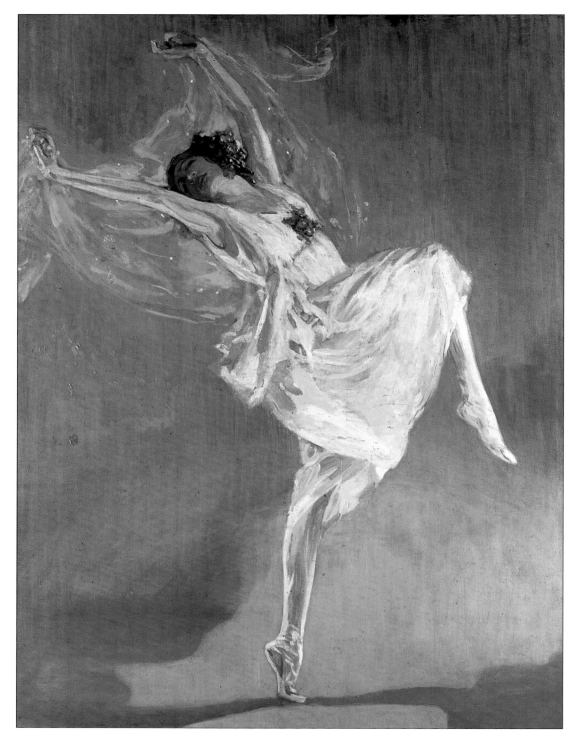

Sir John Lavery

Sir John Lavery's career was a classic 'rags to riches' story. Born in Belfast the son of a wine merchant, when he was three years old his father died in a shipwreck and, to compound the tragedy, his mother died soon after. Lavery was sent to relatives near Moira in County Down. Aged ten, his uncle sent him to school in Ayrshire, but he was unhappy there and ran away to Glasgow, before being returned to Moira. At the age of fifteen he returned to Glasgow, working as a photographer's assistant while attending the Haldane Academy of Art in the evenings.

In 1879 Lavery spent a year at Heatherley's Art School in London before going to the Académie Julian in Paris. There he was taught by William-Adolphe Bouguereau (1825-1905), a traditionalist painter who constantly urged him to 'cherchez la charactère et les valeurs' in his subject-matter, advice which influenced his whole *œuvre* thereafter. In these years the *plein air* naturalism of Jules Bastien-Lepage (1848-84) also had a considerable influence upon him.

In the summer of 1883 Lavery paid the first of several visits to the village of Grez-sur-Loing, south of Paris, a period which he later recalled as the happiest of his life. By late 1884, however, he was back in Glasgow and was being linked to that influential group of painters subsequently known as 'The Glasgow Boys'. This marked the beginning of his meteoric rise to fame, a success which at times dazzled even Lavery himself. In 1888 he was commissioned to paint Queen Victoria's visit to the International Exhibition in Glasgow, which involved painting two hundred and fifty-three portraits, including the Queen herself, in the one painting. It was a resounding success and thus he began to make his name as a portraitist.

In 1896 Lavery moved to London where he was to remain until near the end of his life. In 1910 he married Hazel Martin, an American who became a well-known society hostess; through her Lavery obtained many commissions. During the 1914-18 war he served as an official war artist with the Royal Navy and in 1918 was knighted for his work. In 1921 he and his wife were involved on the periphery of the crucial negotiations in London which led to the Anglo-Irish Treaty and Irish independence.

Lavery's later years were relatively uneventful. In 1921 he became a full academician of the Royal Academy, and after Hazel died in 1935, he spent much time with his step-daughter in Ireland. His memoirs, *The Life of a Painter*, appeared a few months before his death in January 1941.

ANNA PAVLOVA AS A BACCHANTE
1911
OIL ON CANVAS (198.1 x 144.8 CM / 78 x 57 IN.) GLASGOW ART GALLERY AND MUSEUM

THE MADONNA OF THE LAKES

John Lavery was born and spent his first three years in Belfast's North Queen's Street where his father kept a public house. The city at the time was prosperous, the population growing quickly as the industries which were to make it famous – linen and shipbuilding – expanded to cater for new markets. The Laverys lived nearly opposite the Church of St Patrick and it was there that John was christened in March 1856. Years later, during the First World War, Hazel Lavery joined in the popular pastime of posing for tableaux vivants based on famous paintings, and on one occasion she posed as 'A Modern Madonna' to a design by her husband. This pose also served as the centrepiece for *The Madonna of the Lakes* which Lavery presented to St Patrick's Church.

The picture is emotionally evocative, the arrangement of the three figures and the typically Irish landscape – the background is intended to represent the Kerry lakes – playing upon the theme of 'Mother Ireland' and lending a distinct Irish piety to the whole composition. The tapestry of small flowers seen in the foreground, all painted with great care, suggests a promised Eden to which faith will lead, and this contrasts with the rugged and barren terrain behind. The central figure of the Virgin, which is depicted life-size, dominates all and the other figures,

St Patrick on the left and St Brigid on the right, are slightly less than life-size and thus physically as well as emotionally are subjugated to the main figure. Hazel Lavery posed as the Madonna, Eileen, the painter's daughter, posed as St Brigid and Alice, Hazel's daughter by her first marriage, as St Patrick. A special altar (since destroyed) and frame for the triptych was designed by Sir Edwin Lutyens.

The composition is triangular in format, the Virgin's dress flowing in such a manner as to link the two side panels to the main composition. There is an expression of pathos on the Virgin's face and her headdress takes the form of a halo. Her mood is one of sadness, of resignation, and this dominates the whole picture and is echoed too in the facial expressions of the saints on either side of her.

The paint has been handled with a broad brush to suggest a fine, but richly adorned fabric for the Virgin's cloak. There is a heavy impasto in many areas and even the background has been established with a thick layer of paint. The mountains in the background visually halt the eye as it regresses into the composition and thus provide a satisfying setting for the event taking place. Overall, the composition may be read as a statement by Lavery of his feelings, hopes and aspirations for his native land.

1917
TRIPTYCH OIL ON CANVAS (385 x 277 CM / 151¹/₂ x 109 IN. OVERALL)
ST PATRICK'S CHURCH, BELFAST

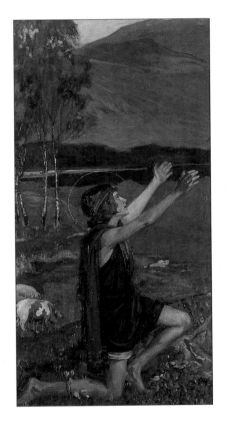
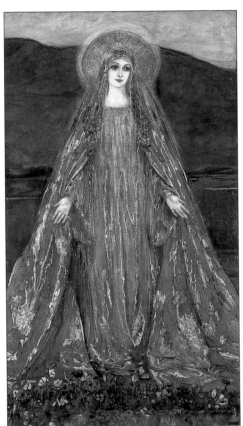

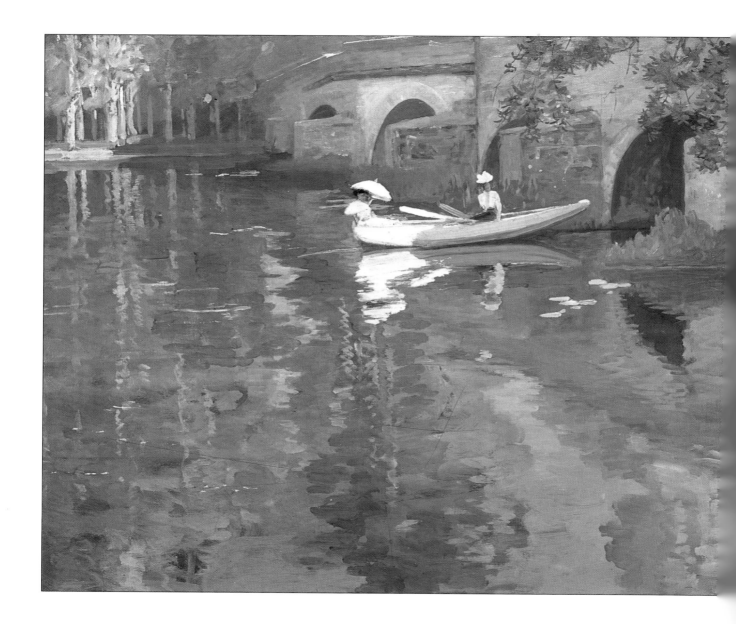

THE BRIDGE AT GREZ

A s an artist, Lavery to a large extent was a chronicler of his times and this picture is delightfully evocative of a bygone era. The distinctive shape of the bridge over the river Loing is clearly defined as a backdrop to the composition, yet, as the rowing boat approaches an archway, one senses an idyllic, never-ending progression in space and time.

In the closing years of the nineteenth century, Grez-sur-Loing was the gathering place of artists of many nationalities. Lavery visited there in the early 1880s and spent a season sketching around the village in 1900. As a result of that last visit he made this composition the following year. The strong sense of light permeating the picture, focusing on the woman with a parasol in the stern of the boat and catching the ripples of the calm stream, betrays the influence of French Impressionism, possibly of Monet, on Lavery at the time. Yet the artist declared himself to be painting without theory: 'I dare say I *should* have learnt more and been more influenced by the influential and impressed by the Impressionists', he once said. Whatever the truth of it, his spontaneous approach to painting produced many memorable images of a gentler age.

1901
OIL ON CANVAS (89.1 x 148.3 CM / 35 x 58¼ IN.)
ULSTER MUSEUM, BELFAST

THE THAMES AT MAIDENHEAD

People at leisure feature frequently in Lavery's subject-matter. From his earliest pictures done in France in the early 1880s, in particular the theme of people lazing in boats in the summer sunshine, usually by a river, is a frequent occurrence in his *œuvre*. Often such images evoke a nostalgia, which is heightened as the gentle flow of the water mimics the passage of time in which we are all entangled.

As the Edwardian era drew to its close in the years before the First World War Lavery and his renowned and beautiful wife Hazel were frequent guests at house parties and other social gatherings given by the aristocratic rich and famous. Lavery, who cared little for such occasions, would often disappear into the background with his paint box and record his fellow guests at they idled the time away. *The Thames at Maidenhead* may have been painted on such an occasion, or perhaps it was just a casual event glanced in passing. At any rate, in it Lavery has caught brilliantly the hedonistic mood and atmosphere both of the scene and of the times. As Kenneth McConkey has commented, such pictures were 'Lavery's

Cythera, his eighteenth-century lotus land of light, calm and voluptuousness'.

The composition clearly recalls versions of *The Bridge at Grez*, notably that of 1883, except that the relative positions of the punt in the foreground and the skiff in the middle distance are here transposed. In each case the emphasis in the composition is on the horizontal, but this is broken here by the slight diagonal positioning of the punt and in the former picture by the thrust of the bridge as it crosses the river. Lavery has rendered the light as it reflects off the water with great skill: the dark hues of the middle distance lend a feeling of depth to the river as they contrast with the lighter strip of grass beyond. The gentle ripples of the water echo the lethargy of the occupants of the punt as they bathe in the sunshine. Interestingly, the bright orange colour of the woman's parasol contrasts vividly with the surrounding blues of the water – orange and blue are complementary colours – in a manner which brings to mind the colour theories of the Post-Impressionists, whose works Lavery would have known as a youth in France.

C. 1913
OIL ON CANVAS (101.6 x 127 CM / 40 x 50 IN.)
PRIVATE COLLECTION, COURTESY OF THE PYMS GALLERY, LONDON

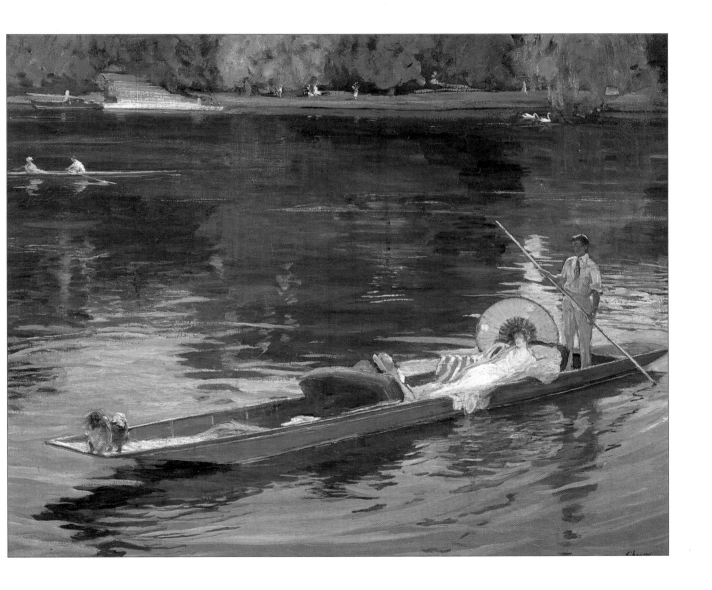

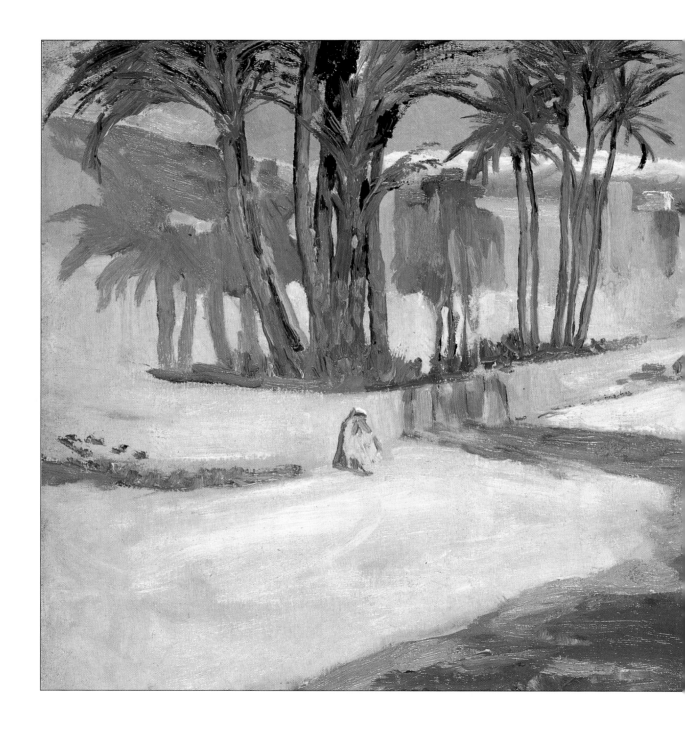

THE WALLS OF MARRAKESH

Lavery paid the first of many visits to Morocco in 1891 and was captivated by the country. Then, and on subsequent visits, he painted its people and its landscape in all seasons. Writing of his liking for the place a friend once commented, in a way which illustrates Lavery's whole manner of working: 'I used to come upon him seated like a fly in amber ... surrounded by a crowd. Moors stood and gazed ... Mules, laden with great trusses of pressed straw, brushed by his easel, and now and then a camel came sailing past, appeared about to take a piece out of his umbrella, as he sat buried in his work ... in ... Tangier he learned the trick of working quite unconcerned by anything that passes in the world'.

This little landscape, set down with great economy of means, captures a scene as passers-by make their way in the late afternoon sun. The long shadows, the juxtaposition of the warm pinks on the city walls, the reds and cool greens in the foreground and the heat of the day are contrasted with the thin air of the snow-capped mountains beyond. The spontaneity of the brushwork – the whole picture must have been painted in a matter of hours – reverberates with the artist's joy.

1920
OIL ON CANVAS (51 x 76.4 CM / 20 x 30 IN.)
ULSTER MUSEUM, BELFAST

Walter Osborne

Walter Osborne was a son of William Osborne (1823-1901), a well-known animal painter. He studied art at the Royal Hibernian Academy School, which he entered in 1876, and at the Metropolitan School of Art, Dublin, and after a distinguished career there (he won the Taylor Scholarship of the Royal Dublin Society) he went in 1881 to Antwerp, where he studied under Charles Verlat (1824-90) at the Académie Royale des Beaux Arts. Thereafter, he travelled to Brittany, painting around Pont Aven, Quimperlé and Dinan and, like many artists of his generation, was influenced by the French naturalist painter Jules Bastien-Lepage.

Following his visits to France he spent some years in England painting scenes of rural folk and the countryside in Berkshire, Norfolk, Sussex and elsewhere, all rendered with great verisimilitude. It was with such works, which he exhibited in Dublin at the Royal Hibernian Academy and in London at the Royal Academy, that he made his reputation.

In the early 1890s Osborne settled permanently in Dublin, although he continued to travel abroad. He visited Spain in 1895 and a year later was in Holland. In 1891 he began exhibiting portraits and soon established a firm reputation in that genre. He was elected an associate member of the RHA in 1883 and a full member in 1886. He taught at the RHA schools for a number of years until his death, his most significant student being W. J. Leech (q.v.). In 1895 he opened a studio at number seven St Stephen's Green, and henceforth (even after his death) that address was a popular venue in the Dublin art world.

Osborne had an engaging personality and was highly regarded by his many friends and contemporaries. In 1900 he was offered a knighthood for his services to art, but for reasons unknown refused the offer. He died tragically young, at the age of forty-three, of pneumonia.

Osborne regularly worked out of doors and his landscapes have a feeling of freshness which have led to him being labelled an Impressionist painter. Yet despite the obvious attractions of this appellation there is about his work a sense of serenity and deliberation which separates him from Impressionism, at least in the strict sense of the term. Had he lived longer, one can only speculate that he might have become more experimental in terms of his handling of paint, use of colour and light.

J . B . S . MACILWAINE
1892
OIL ON CANVAS (61 X 51 CM / 24 X 20 IN.) NATIONAL GALLERY OF IRELAND, DUBLIN

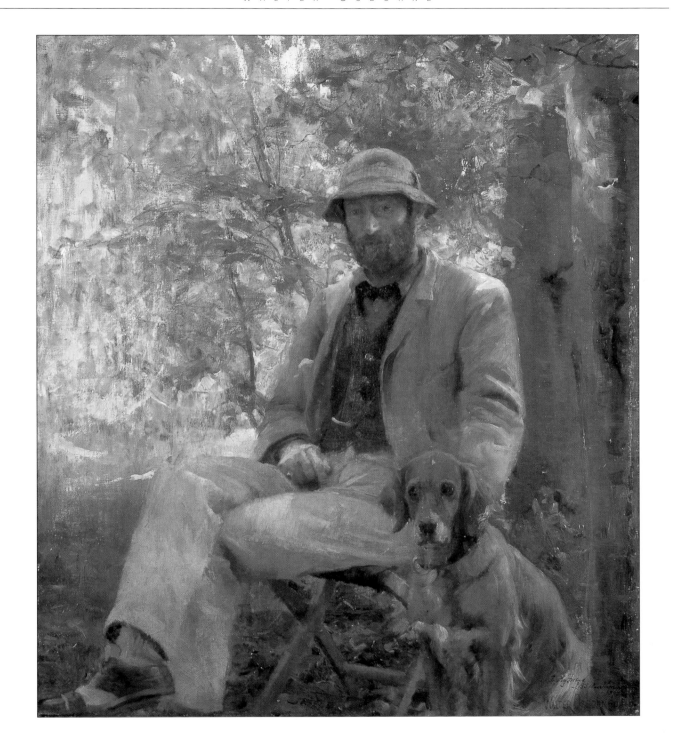

APPLE GATHERING, QUIMPERLÉ

After his departure from Antwerp in 1883 Osborne went to Brittany, where he remained for about a year. Brittany at that time was a popular venue for painters and Osborne was accompanied there by his fellow-Irish artists Nathaniel Hill (1861-1934) and J.M. Kavanagh (1856-1918) who had also been with him in Antwerp. The area was cheap to live in and, with tourists and others, had a cosmopolitan atmosphere. It was a colourful place, both literally and metaphorically, for the native population still wore traditional costume and many were willing to sit for artists for a modest fee. Along with such towns as Concarneau, Dinan and Pont Aven (where Gauguin worked for a spell), Quimperlé was a popular haunt of artists by the time Osborne arrived there. As the writer Henry Blackburn had commented of it a little earlier, 'a painter might well make Quimperlé a centre of operations, for its precincts are little known, and the gardens shine with laden fruits and the hills are rich in colour until late in Autumn'.

Despite the development of Impressionism in the 1870s *Apple Gathering at Quimperlé* is typical of the kind of painting practised at the time by perhaps the majority of avant-garde painters. Painted on the spot, or *en plein air* as the technique was better known, the picture has a high degree of naturalism, but the actual process of painting – the way the paint is laid on the canvas – can be seen to have developed in such a manner as to draw attention to itself, notably by the use of a square-cut brush to model the form of the tree trunk in the foreground and elsewhere in the composition, a development which distances even a work such as this from the academic tradition from which it evolved. The new influence came largely from Bastien-Lepage who had a profound influence on a generation of painters.

The mood evoked by this picture, and the relatively limited range of colours, is characteristic of Osborne's work in general. The inevitable influence on the subject-matter was Jean-François Millet (1814-75), but Osborne lacks his social direction. The composition is simple: an orchard in the foreground, a town behind; the two areas equally occupying the picture plain, linked by the upward rise of an apple tree. The manipulation of the myriad shades and contrasting tones of green in this tree, not to mention those of the foreground, represent a *tour de force* for an artist at the beginning of his career. The clarity of the foreground and the child who knocks apples from their boughs, contrasts with the background buildings which recede in a wistful atmosphere of studied solemnity.

1883
OIL ON CANVAS (58 x 46 CM / 23 x 18 IN.)
NATIONAL GALLERY OF IRELAND, DUBLIN

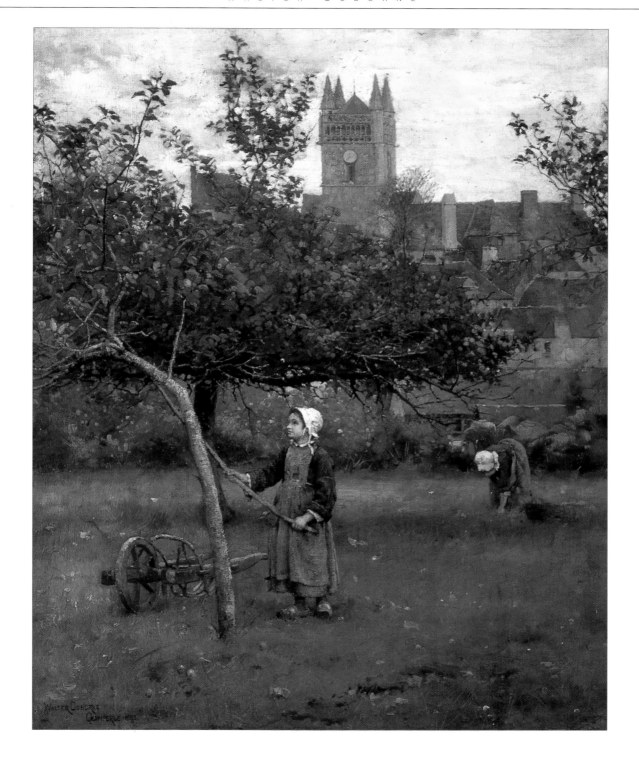

THE ESTUARY AT WALBERSWICK

In the early 1880s Osborne regularly spent time in England, staying in secluded lodgings and painting the local scenery. On what was probably his first visit there, accompanied by Nathaniel Hill, he spent time at Walberswick near the Suffolk coast.

The Estuary at Walberswick is a good example of Osborne's work from this time and shows him at his most naturalistic. The mood is one of tranquillity, as two boys in the foreground laze by the river in idle contemplation; boats are moored or drawn out of the water and all is still. Such landscapes by Osborne invariably contain figures, but, as here, they are subsumed into the overall scheme of things and lack any trace of social or other tension.

The paint has been evenly applied throughout in a sturdy film and there is no emphasis on impasto or *malerisch* brushwork to distract from the serenity of the scene. A good-mannered sensitivity, another characteristic of Osborne's painting at the time, prevails. As Bodkin noted, there is nothing distinctively Irish in Osborne's work; he was, said Bodkin, 'happier in Rye or Walberswick than in Galway'.

1884-5
OIL ON CANVAS (45.5 x 61 CM / 18 x 24 IN.)
ULSTER MUSEUM, BELFAST

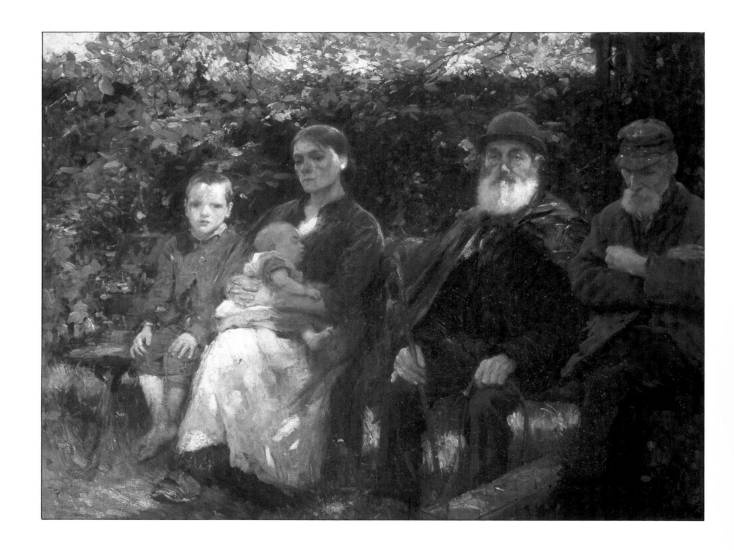

A SCENE IN THE PHOENIX PARK

The dappled sunlight falling upon this picture well illustrates the reason why Osborne has been called Ireland's only Impressionist painter, even if the obvious deliberation of his technique – he would make numerous studies for a composition such as this – separates him from the more spontaneous approach of Impressionism proper. Perhaps his preference for working out of doors, which brought spontaneity, light and atmosphere to his work, was in reality the closest Osborne came to Impressionism, which as a movement was underpinned by a more rigorous exploration of the nature of light and colour than often appears to be the case from Impressionist paintings *per se*. Yet the art critic Thomas MacGreevy was of the opinion that, had Osborne lived, he would certainly have become a genuine Impressionist.

Impressionist or not, this composition is masterly. Four people, including one woman with a child in her arms, all obviously in great poverty, are seated upon a park bench in the shade of the sun. Each is lost in thought and none engages us as we look upon them. The real subject-matter of this genre picture, however, is not the group of people, but light, which is diffused as it falls through the overhanging panoply of foliage.

The light catches the figures only a little, but sufficiently to give prominence to a facial expression, a hand or other feature. Compositionally, the area of relative shadow to the right contrasts with the whole left-hand side which is bathed in light. Characteristically for Osborne, the range of colours is subdued, most of the scene being dominated by the dark browns and umbers of the figure group, while much of the periphery is sun-drenched. The sunlit foliage behind the figures, however, stands out from the shaded wall in the background to give a sense of space and volume. The paint has been evenly applied throughout, with little evidence of impasto. The execution is brisk and the paint is fresh, descriptively applied and un-laboured.

The picture is in a sense a social document. The overall impression made by it is of rest and tranquillity. Here is a world, a way of life, a class system even, which has existed unchanged for generations. Yet, withal, Osborne's is not a didactic view; rather he is content to allow us, as spectators, to bring our own observations to the scene – one which is a real *tour de force* for a young artist of just thirty-six years of age.

c. 1895
OIL ON CANVAS (71 x 91 CM / 28 x 36 IN.)
NATIONAL GALLERY OF IRELAND, DUBLIN

MRS NOEL GUINNESS AND HER DAUGHTER MARGARET

In the early 1890s Osborne turned increasingly to portrait painting. Why he did so is unclear, but the decision was almost certainly dictated by financial reasons for increasingly he had his family – his aged father, his mother going blind and his young niece – to support. It was a wise move, since before long he was regarded as Dublin's premier portraitist and in time was to paint many notable Irish men and women. Even so, his portraits were not universally admired and the more formal ones were sometimes a trifle stiff, lacking in personality. However, he was more successful when painting women than men, especially when the sitter was a friend or someone he knew and with whom he had a rapport, as his studies of *Mrs Andrew Jameson and her Daughter Violet* (c.1895-6), *Miss Honor O'Brien* (c. 1898) – Osborne thought he was at his best in this work – *Master Aubrey Gwynn* (1896) and *Mrs Noel Guinness and her daughter Margaret* all demonstrate.

Mrs Noel Guinness and her daughter Margaret is one of his finest achievements and one of the best known of all his commissioned portraits. It has, in the words of Anne Crookshank and The Knight of Glin, a 'charming informality'. The portrait shows Mrs Guinness seated with her young daughter standing on the chair beside

her. The composition has a diagonal thrust which, given the shape of the interior, brings a degree of spatial awareness, even theatricality, to the composition. Osborne may have been influenced by Whistler's celebrated *Portrait of Thomas Carlyle*, which he would have seen at the Dublin Sketching Club's annual exhibition of 1884 and which employs a similar compositional technique, or by Velazquez, whom he would have seen in the Prado during his visit to Madrid with Sir Walter Armstrong in 1895.

The principal charm of the picture lies in its naturalism and the obvious bond between the two figures: the mother as she reads a story to her daughter from a book, and the child who is lost in her own little dream world. The theatricality inherent in the work is heightened by the play of light which is confined to the figures, which thus contrast with the darkness of the rest of the interior. The painting of the mother's dress, with its restrained floral pattern, is delicate and shows Osborne at the height of his powers. Although Bodkin disliked Osborne's portrait work in general, he thought this piece reached 'a high degree of excellence', as the judges concurred when it was awarded a bronze medal at the Paris International Exhibition of 1900.

1898
OIL ON CANVAS (137.2 x 152.4 CM / 54 x 60 IN.)
PRIVATE COLLECTION

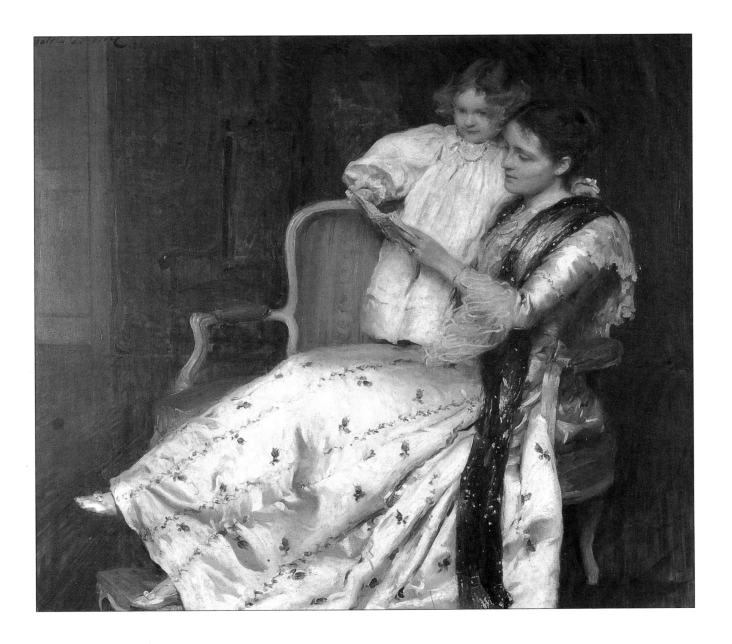

Roderic O'Conor

Roderic O'Conor was a painter and engraver of landscapes, still lifes and portraits. Educated at the Metropolitan School of Art in Dublin, O'Conor then went, in 1883, in the footsteps of other Irish artists to Antwerp, to the Académie Royale des Beaux Arts where he was a pupil of Charles Verlat and where he was influenced by the prevailing interest in *plein air* painting. In the late summer of 1884 he returned to Dublin, but in 1886 he moved to Paris to study under the celebrated portrait painter Carolus-Duran (1838-1917), whose lasting influence on him was, perhaps, the ability to work directly without elaborate preparatory studies. Thereafter, while he paid periodic visits to Ireland, he never lived there again.

O'Conor was typical of many of painters of his time in that he had sufficient private means to ensure he didn't have to work. There was no pressure upon him to exhibit and sell his paintings: he never needed his art as a support. His well-to-do background – he was the son of the high sheriff of Roscommon and heir to a substantial estate – enabled him to travel freely and in 1889 he moved to the artists' colony at Grez-sur-Loing, some seventy miles south-east of Paris. There he turned to Impressionism, being influenced by the work of Claude Monet and Alfred Sisley. But soon he came under the influence of Vincent van Gogh and Paul Gauguin, and this was to be a turning point. In 1891 he visited Pont Aven, the then fashionable resort for painters in Brittany, and began what was to be a decade of close association with the village and its artistic community. While there he adopted a sort of Divisionist manner, thus aligning himself with the most radical painters. In 1894, in Pont Aven, he developed a close friendship with Gauguin, who had a profound influence on his work. These years were the most crucial stage in O'Conor's career.

In 1904 O'Conor left Brittany for Paris. There he was identified with many progressive artists, but he maintained links with Irish painters and others with Irish connections. In Paris he met Clive Bell, Roger Fry and Matthew Smith and through them came into contact with Bloomsbury and the English avant-garde. In 1933 he married Renée Honta, his model, and moved to Nueil-sur-Layon, where he lived until his death. While O'Conor was one of the most radical Irish painters of his generation, his absence from Ireland for most of his career meant that his work had little influence at home.

LA JEUNE FILLE
c. 1920
OIL ON CANVAS (91.4 x 72.4 CM / 36 x 28 1/2 IN.) PRIVATE COLLECTION

FIELD OF CORN, PONT AVEN

In choosing to study at the Académie Royale des Beaux Arts in Antwerp O'Conor followed in the path of several of his Irish contemporaries. There he would have been instructed in a fairly academic manner, although his teacher, Charles Verlat, encouraged his pupils to work briskly and spontaneously, without elaborate preparatory sketches, and Verlat himself had a liking for thick paint and bright colours. Yet despite Verlat's relative modernity of approach, most of his pupils continued to work in a traditional style. But O'Conor was a man of independent mind, and his teacher's liking for a *malerisch* technique and bright colours obviously impressed themselves upon him, as can be seen for example in his *Between the Cliffs, Aberystwyth* (c. 1883-4), one of his earliest surviving paintings. Later, in Paris, Carolus-Duran would encourage a similarly direct approach, emphasizing the relationship between form and colour from the outset. For O'Conor, the later adoption of an Impressionist technique, with its emphasis on light and colour, must have seemed, therefore, a natural development.

Field of Corn, Pont Aven illustrates a stage of evolution in O'Conor's painting between his Impressionist pictures of the late 1880s and his semi-Divisionist, or 'striped' manner of the early and mid-1890s. Here the terrain is still rendered in a recognizable fashion, but nevertheless O'Conor is clearly more interested in the technique of painting, and in colour *per se*, than in producing a naturalistic rendering of the scene. His impassioned approach to his subject suggests the influence of Van Gogh, but the brushwork also recalls Verlat. In the foreground the writhing movement of the corn is rendered superbly in anguished, yet descriptive, brushwork, but beyond this everything else in the composition appeals to one's sense of colour. At the left a shadow is cast – probably from an unseen tree – but instead of painting the corn in darker tones of its own colour O'Conor has employed contrasting complementary colours, reds and greens, mixed with blues which in turn contrast with the yellows and oranges in the corn. The distant hillside and clumps of trees are set down in a striped technique (which he had developed a year or so earlier) of contrasting greens, oranges and reds; while the light cobalt blue overlaid with strokes of green in the sky produces a vibrant effect.

The picture is thus to be read primarily in terms of colour and not topography. In the early 1890s, it was, perhaps, the most advanced composition from the hand of an Irish artist of its time.

1892
OIL ON CANVAS (38 x 38 CM / 15 x 15 IN.)
ULSTER MUSEUM, BELFAST

ANEMONES

After his move to Paris in 1904 O'Conor largely abandoned landscapes, seascapes and portraiture as his subject-matter and turned to flower paintings, still lifes and interiors with figures, often nudes. The setting of a proper studio (in the Montparnasse area of the city, a popular artists' haunt of the day) afforded him the possibility of controlling the lighting, the mood and atmosphere of the scene more than ever before, and this no doubt influenced his choice of subject.

In particular O'Conor painted flowers with great sensitivity. Usually he would place the 'arrangement' beside the studio window so that the flowers catch a good light, which in turn emphasizes the strength of the colours. Yet despite careful planning, the precise context is rarely of any importance, as one's attention is concentrated solely upon the flowers themselves.

Anemones is a good example of his approach. The whole emphasis in the composition is on spontaneity. Having established the setting, the background is merely indicated in the most unsubstantial terms, the paint being stained onto the canvas in washes with a wide brush, while large areas of unpainted canvas are allowed to show through, the effect being to lend a luminosity to the whole. Apart from a few accentuated shadows, which give a sense of space and volume to the scene, there is no meaningful modelling of shapes or forms to detract one's attention from the resplendence of the flowers. Thus the actual arrangement is both literally and aesthetically given full prominence. As has often been remarked of O'Conor, while there may be traces of symbolism in some of his pictures, generally this is of a 'painterly' rather than a 'literary' character, for above all O'Conor remained an observer of nature.

The particular attractiveness of the *Anemones* composition is brought about through the juxtaposition of dark tones, especially those in the foliage, and the play of complementary colours (reds and greens) one with another, for these lend a dramatic vivacity to the picture. This is heightened by the sense of movement inherent in the foliage. The painting of the flowers, as with the background, has been briskly done, but the evident impasto here and there brings texture to an otherwise lightly painted surface.

c. 1910
OIL ON CANVAS (65 x 54 CM / 25^1/$_2$ x 21 IN.)
AIB ART COLLECTION, DUBLIN

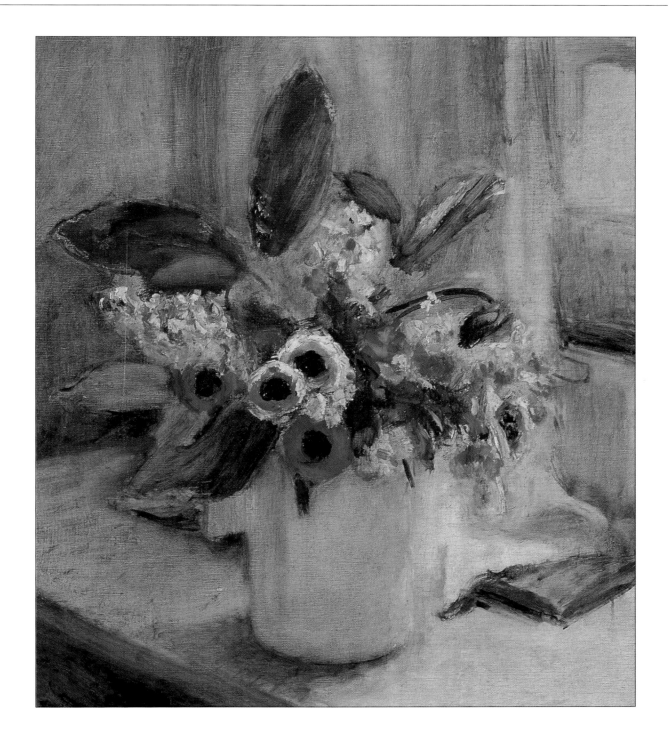

RED ROCKS NEAR PONT AVEN

In 1898 O'Conor painted a number of seascapes which, like this one, depict the almost pungent red rock formations of the Breton coast with the sea breaking upon them. These pictures are in part cathartic – a homage to the forces of nature, even – for since the death of his father (1893) and the departure of his friend Gauguin for the South Seas (1895), O'Conor had felt lonely and isolated; he had been ill too for a time. But he was also questioning the direction in which his work was developing and so these sea paintings may be seen as experiments in a changing style.

Characteristic of his new style is a greater fluency – often verging on a *joie de vivre* – in his handling of paint. *Red Rocks near Pont Aven* well illustrates this development. The scene itself is more naturalistically rendered than in recent works, but the emphasis on the visual play of one colour with another remains from before. The use of the paint, heavily laden with oil, is sensuous throughout, and the clear light shines as a signal to the life ahead. For O'Conor, the existential act of painting is here a pure delight.

1898
OIL ON PAPER ON BOARD (25 x 35.5 CM / 10 x 14 IN.)
AIB ART COLLECTION, DUBLIN

George Russell (Æ)

As a painter, writer, poet, critic, theosophist and economist George Russell, better known by his pen name 'Æ', was something of a polymath. He grew up in Lurgan, County Armagh, and in 1878 went to Dublin with his family. There he attended evening classes at the Metropolitan School of Art (where he was a contemporary of W.B. Yeats who became his life-long friend), and, later, the Royal Hibernian Academy School. His early art work consisted of humorous cartoons and mystic watercolour sketches in which he set down his 'visions'– Yeats once called him 'a mystic of mediaeval type'. He began work as a clerk at Pim's drapers in 1890, but in 1897 accepted a post from Horace Plunkett to organize the economic affairs of the Irish Agricultural Organisation Society (IAOS) in the west of Ireland, and he was to retain links with the IAOS for many years. During the 1890s he joined the Dublin branch of the Theosophical Society and for a time even lived in an experimental community at the Society's headquarters, three Upper Ely Place.

A supporter of Hugh Lane's efforts to establish a gallery of modern art in Dublin, Russell's own paintings were represented in a number of notable exhibitions, including the celebrated Armory Show in New York (the American collector John Quinn probably saw to his inclusion) and the exhibition of Irish art held at the Whitechapel Art Gallery, London, in 1913. Russell, who has often been called a 'Sunday' painter, made few claims for his art, yet he was one of a small number of Irish artists who tried to relate his work to the Celtic heritage.

Besides his work as a painter and an economist, Russell was prolific as a writer, critic, poet and lecturer, and was a central figure in the early years of the Irish literary revival. His *Collected Poems* were published in 1913 with a second edition in 1926; he also published novels and plays. He was editor of the *Irish Homestead*, the official organ of the IAOS, from 1903 till 1924 and of the *Irish Statesman* from 1923 till 1930. In 1932 Æ was one of the founder members of the Irish Academy of Letters.

To Russell his multifarious activities were complementary. As George Moore noted, with him art was 'a means rather than an end'; yet it should be sought, Æ believed, 'for by its help we can live more purely, more intensely, but we must never forget that to live as fully as possible is … our main concern'. After his wife's death in 1932 Russell spent his final years in England.

Morning of Life
c. 1920s
Oil on canvas (40.7 x 53.3 cm / 16 x 21 in.)
Private Collection

THE WATCHER

This is one of Æ's most straightforward representational landscapes. Yet even in compositions like this he was concerned with the spirit of the place. 'When I am painting a little scene in Connemara or a bogland stretch, the people of the bog are part of my landscape,' he wrote. 'They grow up with it and form themselves. The bog is not the picture, nor the people, but all seem to me part of one being'. And he told his friend John Quinn in America: 'What I want to do is to paint landscape as if it had no existence than in the imagination of the Divine Mind, to paint man as if his life overflowed into that imagination, and to paint the Sidhe as mingling with that life: indeed, the unity of God and man and nature in one single being – an almost impossible idea to convey in paint'.

In *The Watcher* the mood of the scene, with its subdued colours, evening light, a young woman sitting pensively by a bog pool, is slightly ethereal, a subtle reminder that we are irrevocably rooted to the land which supports us.

c. 1920s
OIL ON CANVAS (53.6 x 81.6 CM / 21 x 32 IN.)
ULSTER MUSEUM, BELFAST

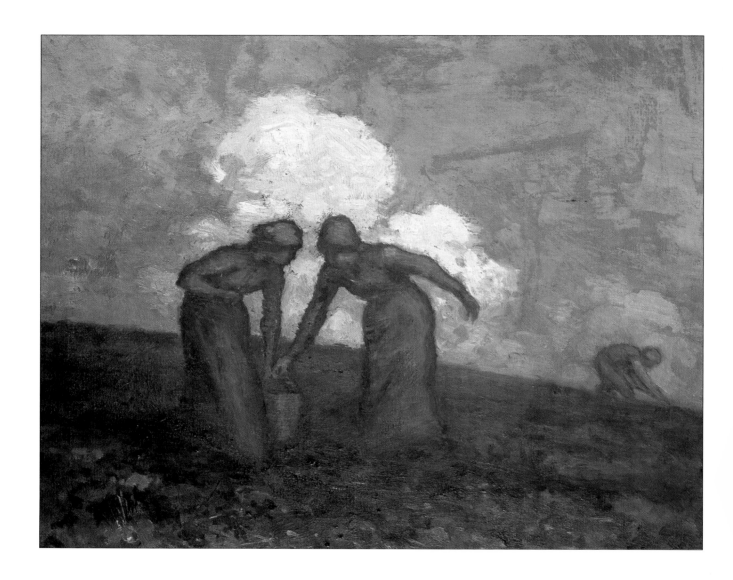

THE POTATO GATHERERS

While at the Dublin Metropolitan School of Art Russell began to make drawings and paintings, usually in pastels, of the visions which he claimed to have seen, and it was for such images that he first became known. 'He never painted an other-world figure unless he had actually seen it', James Stephens wrote many years later. Russell, he said, 'would shut his eyes, and look at them [i.e. the 'Sidhe', the invisible inhabitants of Ireland] in a darkness that he lit up for himself. He held that the light and colour you awaken inside your head is much more vivid than the same happening outside your head … he saw with real insight, and that these extra-terrestrial beings were actually there, were most truly visible to the inward eye'. In 1892, while living at the Theosophical Lodge in Dublin, Æ painted on the walls of the Lodge a number of murals. His subject-matter in these was 'the journey of the pilgrim soul' and they show spirit figures, planets, stars and otherworldly light. An influence on them may have come from the works of William Blake and the French Symbolist painter, Odilon Redon. Apart from these murals Æ painted little until about 1902, by which time he had left the Theosophical Society, married and started to work for the Irish Agricultural Organisation Society.

In about 1902 Æ began to paint in oils, making landscape studies which often combined with figures to produce a sort of genre scene. He was at the time influenced by the French painters Jean-François Millet and Gustave Courbet (1819-77), as *The Potato Gatherers* illustrates. The choice of dark colours here suggests an early work. Colour was important to Æ who wrote about relationships between colours, sounds and forms, noting that 'correspondences enable us to understand the language which the gods speak to us through flowers, trees and natural forms'.

The Potato Gatherers is arguably Æ's masterpiece. The paint has been handled in a brisk, loosely Impressionist manner, the debt to Millet being obvious. The compositional technique is almost Post-Impressionist in its rigorous simplicity (although Æ detested the Post-Impressionists), with a two-part division of the picture plane, the upward movement of the figures linking these two parts. The figures have been set down in the simplest terms with limited modelling and with little definition in the massing of the foreground where the paint has been applied in a scumbled manner. The main effect of the work is derived from its sombre, even nostalgic mood which is tinged with pathos, an effect heightened by the setting sun, and its suggestion of the passing of an era.

C. 1904-7
OIL ON CANVAS (48 X 58 CM / 19 X 23 IN.)
ARMAGH COUNTY MUSEUM

Grace Henry

Grace Henry was born Emily Grace Mitchell, the second youngest of ten children of the Rev. John Mitchell, a minister of the Church of Scotland, and his wife Jane, the daughter of wealthy London merchants. Educated privately, and after attending finishing school, Grace, in her mid-twenties, took up painting. In 1899 she went to Brussels to study under Ernest Blanc-Garrins (1843-1916), and the following year moved to Paris, where she enrolled as a student in the atelier of Delacluse. At about that time she met the painter Paul Henry (q.v.) whom, in 1903, she married.

The Henrys lived in and around London until 1910 when, on the advice of a friend, they took a holiday to Achill Island, off the west coast of Co. Mayo. Paul, in particular, was so enamoured of the place that they decided to stay and the island became their headquarters for most of the time until 1919 when they moved to Dublin. During those years both Grace, who alas grew tired of the isolation of Achill, and Paul held annual exhibitions, in their joint names, in Belfast and Dublin, showing mainly landscapes and figure compositions inspired by the harsh landscape of the West. It was with these pictures that they made their reputations.

The decade that followed their move to Dublin was an unhappy time for the Henrys. Gradually, amid domestic and financial difficulties, their marriage began to fail as they drifted apart, each going their own way and finding their own subject-matter, although they continued to hold joint exhibitions. In that decade Grace worked intermittently in France with the Spanish artist Garrido, and with François Guelvec and André Lhote (1885-1962), and she made painting expeditions from time to time to the Italian Lakes and the area around Venice. These visits, however, added to their financial problems and the marriage came under strain: eventually in 1930 she and Paul separated, although they never divorced.

Thereafter Grace led a rootless existence, often travelling and painting abroad, although after the outbreak of war in 1939 she remained in Ireland. With her husband, she had been a founder member of the Society of Dublin Painters in 1920 and she continued to exhibit there for much of her life. In 1949, to her great pleasure, she was elected an Honorary Academician of the Royal Hibernian Academy, another venue at which, in her later years, she had been a regular exhibitor.

THE GIRL IN WHITE
BEFORE 1910
OIL ON CANVAS (61 x 51 CM / 24 x 20 IN.) HUGH LANE MUNICIPAL GALLERY OF MODERN ART, DUBLIN

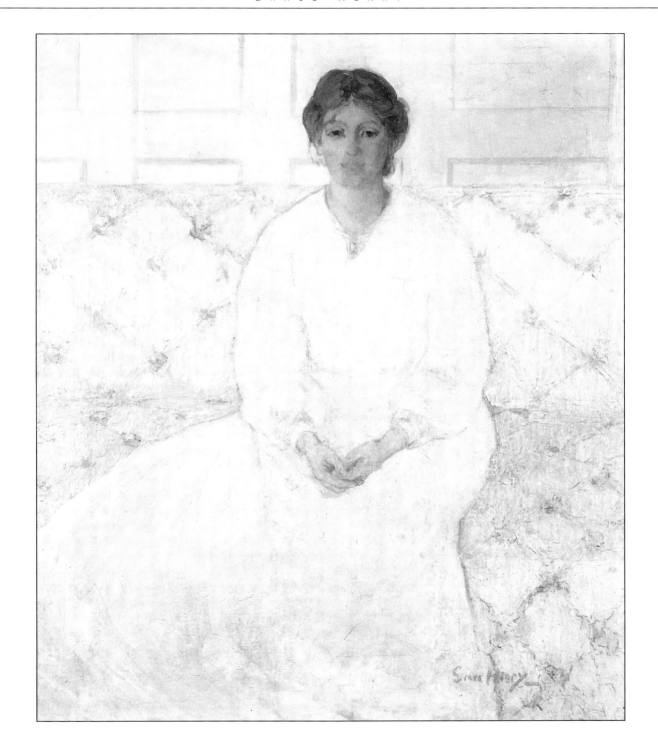

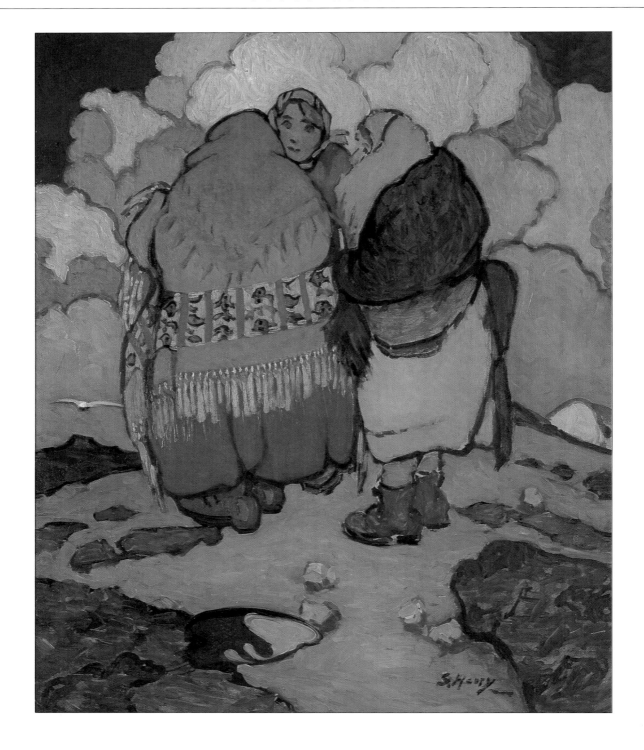

THE TOP OF THE HILL

Although Grace Henry settled with her husband on Achill in 1910 she was never as enthusiastic about the rugged landscape as he was. In truth, by this time Grace was forty-two years old and, in her youth having been used to almost a 'country house' existence, Achill must have seemed alien to her. Indeed, writing about Grace on Achill, Jimmy Good, a friend, commented as early as 1911 that she was unhappy there, although he said she protested that she liked it. But by 1916 Good recorded that 'Mrs Henry … needs to be cheered up; Achill is for her I think a near approach to purgatory'.

Despite the fact that the Henrys were living and working closely together, and drawing upon the same subject-matter in these years, they each developed a distinct manner. *The Top of the Hill*, which was originally entitled *Achill Women*, shows Grace at a relatively early stage of her development as a painter. The illustrative treatment of the subject contrasts with the more *malerisch* treatment typical of Paul Henry in these years, but is common to a number of Grace's early works. As here, figures of young girls predominate in many of her early pictures and they frequently wear a coy, almost furtive expression as, for example, can be seen in *The Black Shawl* (c. 1916-18) or even in the more extrovert *Mallarany*. Reviewing Grace's joint exhibition with Paul Henry in Belfast in March 1915 the *Northern Whig* newspaper admired her gift of observation and ability to capture local life – 'she has the keenest eye for its everyday realities', said the paper. *The Top of the Hill* was almost certainly included in that exhibition and it clearly echoes the *Whig*'s comments, for here we have a group of women huddled closely together and deep in conversation – perhaps gossip – oblivious to their surroundings. The setting shows the barren and rugged terrain characteristic of Achill Island in those days (it is now a more cultivated landscape) and by placing the figures on the top of a gentle rise and silhouetted against the billowing clouds of a dark sky, Henry has created a degree of drama from the scene. Her use of a dark brown line to outline the various forms, figures, terrain, clouds and so on, gives a distinct character to her early work. Her range of colours is limited, being almost monochromatic except for the strongly patterned red shawl worn by the figure to the left of the central group, while her use of a small brush and carefully applied paint throughout echoes her husband's technique in these years.

C. 1914-15
OIL ON CANVAS (61 x 50.5 CM / 24 x 20 IN.)
LIMERICK ART GALLERY

THE RED HOUSE AT MOUGINS

After she settled in Dublin in 1919 the mildly narrative element which hitherto typified much of Grace Henry's work gave way to an experimental, often semi-Expressionist treatment of her subject-matter. Her *Spring in Winter No. 9* (c. 1920-25), for example, shows this stage of development at its most rigorous, the feverish brushwork and jarring contrasts of reds and greens probably being determined by her emotions at the time, for during the 1920s her marriage deteriorated and, in 1930, she finally separated from her husband, Paul. Sadly, despite the separation she retained an affection for Paul, but this was not reciprocated and thus the last decades of her life, while fruitful in an artistic sense, had a prolonged melancholy for her.

In the 1930s, however, Grace spent several periods abroad, painting landscapes in France, Spain and Italy, where the bright sunshine brought a *joie de vivre* to her work and where she produced some of her best-remembered pictures. *The Red House at Mougins* was painted at this time and shows her in a light-hearted mood. Painted at the village of Mougins, a few miles north of Cannes in the Alpes-Maritimes, the house in the composition may have been a stopping place for the artist. Here, in a picture which owes a good deal to French Fauvist painting, we see her at her most effervescent. The composition is dominated by the bright orange-red colour of the house itself, bathed, shutters drawn, in the warm sunshine. The blue of the shutters, being the complementary colour to the predominating orange-red, has thus a contrasting vibrancy which brings real resonance to the image. In front of the house are some green shrubs, but the exuberance of the composition is completed by the two glorious flowering cherry trees which dominate the foreground. The brushwork in these, and indeed throughout the work, has been applied with great fervour: the artist painting only to please herself and her personality comes through clearly.

The breadth of concept and fluidity of execution evident in *The Red House* place Grace Henry among the more innovative painters of her generation working in Ireland. Both she, and works such as this, are typical of those who belonged to and exhibited at the Society of Dublin Painters, a coterie which, until the advent of the Irish Exhibition of Living Art in 1943, represented the best of the Irish avant-garde.

1935-6
OIL ON BOARD (26.6 x 34.6 CM / 10^1/$_2$ x 13^1/$_2$ IN.)
PRIVATE COLLECTION

B. LONDON 1871

Jack B. Yeats

D. DUBLIN 1957

Jack B. Yeats is generally recognized as the most important Irish painter to have emerged this century. Typically, he worked from what he called 'a pool of memories', in his early work often recording the momentous events of the times in which he lived and, later, exploring his innermost thoughts and feelings concerning that world. Always an individualist, his work, particularly that of his late years, is often enigmatic in concept and Expressionistic in execution.

Yeats was the youngest of four surviving children of the painter John Butler Yeats (1839-1922). As a child he was brought up mainly by his grandparents, William and Elizabeth Pollexfen, in Sligo while his parents remained in Dublin where his father worked for a time as a portrait painter. At the age of sixteen he joined his parents in London and began to study art, attending classes sporadically at the South Kensington, Chiswick and Westminster schools of art. In 1888 he set up as a graphic artist, illustrator and watercolourist and provided illustrations for *The Vegetarian*, *Ariel*, *Paddock Life*, *Lika Joko* and other journals. In 1897 he went to live in Strete, Devon, and there began to concentrate his attention on painting in watercolours. Although his earliest oils

date from this time, he did not work regularly in that medium until 1906, in which year he illustrated Synge's *The Aran Islands*. In 1910 he returned to Ireland, for some years settling in Greystones, County Wicklow, but in 1917 moved to Dublin, where he remained for the last forty years of his life.

Yeats exhibited widely and frequently, holding one-man exhibitions in Dublin almost yearly from 1899 till 1955 and others in London and, occasionally, elsewhere in England, as well as in New York, Boston and Paris. He also contributed regularly to mixed exhibitions in Ireland, Europe and the United States. He first showed at the Royal Hibernian Academy in 1895 and, apart from the decade 1901-10, exhibited there annually thereafter over a long and active career. He was elected an associate member of the Academy in 1915 and a full member in 1916; in 1949 he became an Officer of the Légion d'honneur.

Throughout his life Jack Yeats was also active as a writer, producing plays, novels and other prose works and indeed he often preferred the company of writers to artists. Amongst his numerous publications are *Sligo* (1930), *Sailing, Sailing Swiftly* and *Apparitions* (both 1933) and *The Careless Flower* (1947). His *Collected Plays* were published in 1971.

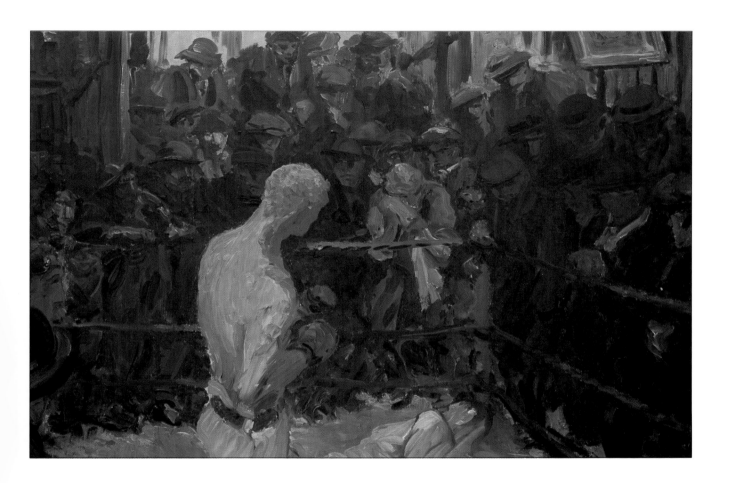

THE SMALL RING
1930
OIL ON CANVAS (61 X 91.5 CM / 24 X 36 IN.)
CRAWFORD ART GALLERY, CORK

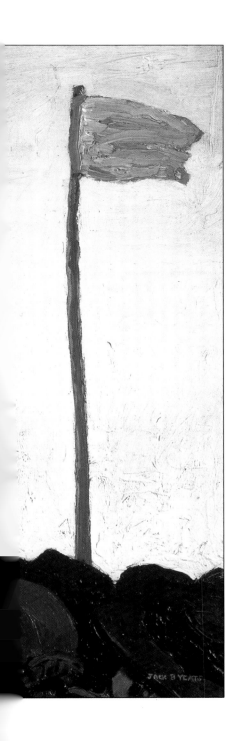

BEFORE THE START

Much of Yeats' subject-matter was drawn from the world around him. Until the mid-1920s his work is largely descriptive in concept and execution; people preoccupy him, although famously horses, and occasionally donkeys, feature prominently in many of his compositions. The true painter, he believed, must be part of the life he paints, although Yeats always painted only to please himself. To him painting was the freest and greatest means of communication.

As here, Yeats often employed a low horizon in his early landscapes, emphasizing the upward thrust of a figure, in part silhouetted against the sky. This device allowed his figures to grow out of their environment and is one that may have been derived from the influence of Edgar Degas, possibly via Walter Sickert, but this is not certain.

Yeats painted many pictures of race meetings. Even in this early work one can see the emphasis on character and expression which were to remain typical of his *œuvre*. His brushwork is concisely descriptive of the forms he is modelling and the heavily applied paint too characterizes his early work. The raised flag lends a sense of tension, of occasion, to an otherwise ordinary scene.

1915
OIL ON CANVAS (46 x 61 CM / 18 x 24 IN.)
NATIONAL GALLERY OF IRELAND, DUBLIN

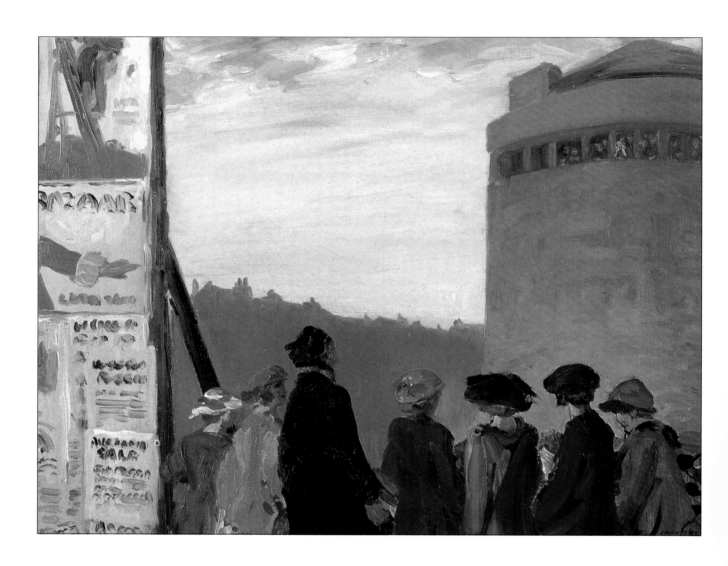

C O M M U N I C A T I N G W I T H P R I S O N E R S

Throughout his life Yeats was a staunch republican, although he took no active part in politics. His subject-matter was always essentially realistic, relating to the people and events around him, which in the Ireland of his youth was, at least superficially, a gay and romantic time. But by the early years of the twentieth century change was afoot, and Yeats was to witness the turbulence which preceded the Easter rising and the violence and bitterness of the Anglo-Irish War and the subsequent Civil War. Although he empathized with those who were caught up in these events, like his brother W.B. Yeats, he nevertheless continued as an observer, he did not participate. But as Hilary Pyle, his biographer, has perceptively noted, in his work he depicts not the conflict itself but the tragedy of conflict for those who remain, and as proof of this she terms several compositions – *Bachelor's Walk: In Memory* (1915) and *The Funeral of Harry Boland* (1922), for example – as elegies. But while Yeats may have been an observer, he is a sensitive one, never complacent in his rhetoric.

Communicating with Prisoners is also an elegy. The subject, a scene in Dublin during the Civil War, depicts a group of women in the street calling to some women prisoners held high up in the sinister-looking tower of Kilmainham Jail. There is nothing heroic about either of these groups of women; they are everyday people with a degree of resignation which seems to symbolize the condition of Ireland at that time. Paradoxically the stoicism evinced by the composition emphasizes both the ordinary and the extraordinary nature of the occasion, veritably elevating it as part of the national psyche. As Thomas MacGreevy noted of pictures like this, in representing such people, unencumbered by class or affectation, Yeats painted 'the Ireland that matters', those ordinary people of whom in his art he was a constant champion.

The compositional technique here is simple, yet dramatic. As observers we share the same eye-level as the spectators in the scene and find ourselves literally – and, importantly, metaphorically too – looking up to those imprisoned. We are thus drawn into the composition and so participate with those assembled. The paint has been evenly applied to the canvas with calm deliberation and, as Hilary Pyle has suggested, the limited range of colours – monochromatic in the background, an occasional red hat or yellow coat in the foreground – gives the effect of a photograph, which indeed may have been the source of the idea for the painting.

c. 1924
OIL ON CANVAS (46 x 61.5 CM / 18 x 24 IN.)
SLIGO COUNTY MUSEUM AND ART GALLERY

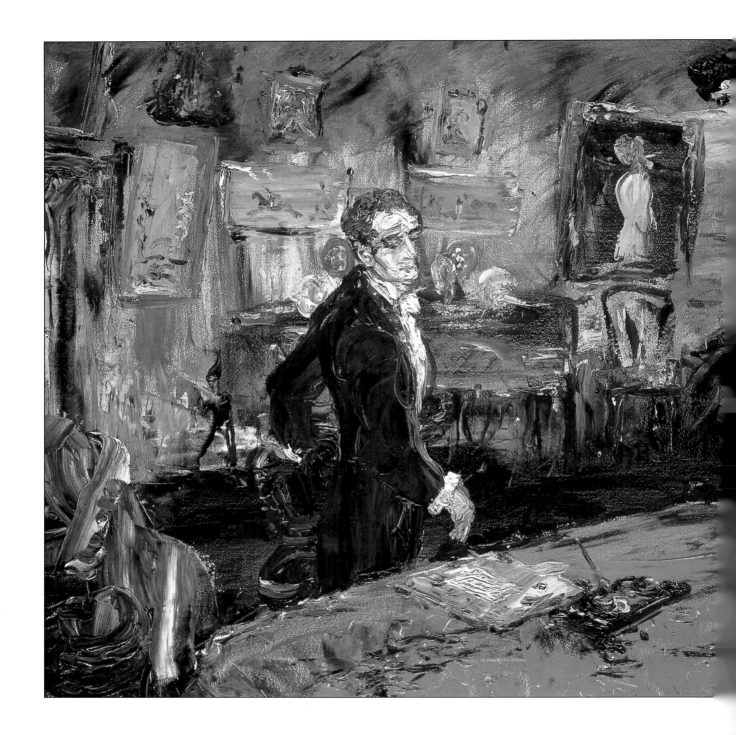

About to Write a Letter

In this, one of Yeats' most powerful works, we are in a room richly furnished with paintings and trophies, these images possibly having a bearing on the decision about to be made by a lone man who stands before a table empty but for the paper and inkstand upon it. The atmosphere is mysterious — we do not know what the man is thinking. Yet there are clues as to the drama of the scene in Yeats' use of red and green. Metaphorically, the red (symbolic of emotion, even danger) towards which the man half turns hints at a demanding future; while the cooler background green, with its trophies and other images, may evoke an eventful, though now receding, past.

The picture marks a stage in the development of Yeats' mature style of Expressionist brushwork and loosely indicated forms, and indeed the subject may in part be autobiographical, for this new technique coincided not only with the artist's advancing age — he was sixty-four when this work was painted — but also with the dark clouds which were starting to settle over Europe as the decade drifted towards the Second World War. Yeats was one of the few Irish painters to take a broad view of those years, increasingly appreciating the universality of the plight of mankind.

1935
OIL ON CANVAS (61 x 91.5 CM / 24 x 36 IN.)
NATIONAL GALLERY OF IRELAND, DUBLIN

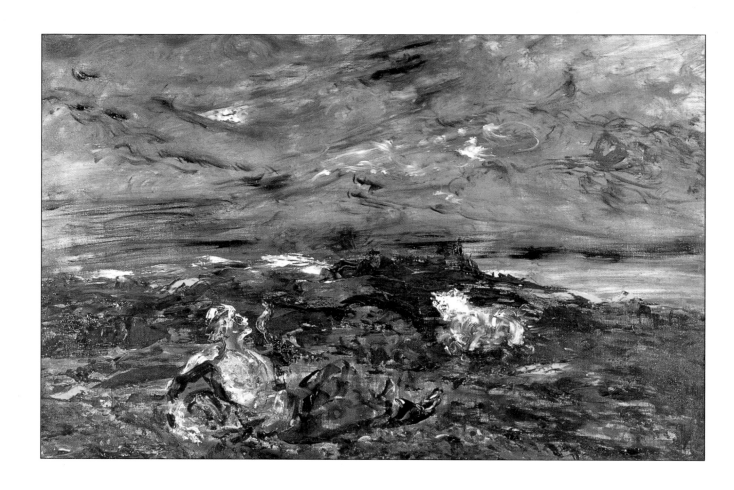

THERE IS NO NIGHT

This picture, as with much of Yeats' late work, has both an autobiographical feeling to it and a sense of the universal in terms of our collective experience of life. In 1947 Yeats' wife, Cottie, died after a long illness and shortly afterwards he completed a number of pictures which express his extreme sense of her loss. One of these pictures, representing the artist walking alone in a landscape at daybreak, was entitled *The Night has Gone* (1947). In part it represents his relief at the end of his wife's suffering, while also symbolizing the new, if lonely, life now before him.

Two years later in *There is No Night* Yeats returned, with optimism, to the subject portraying a lone traveller (himself?), again at daybreak, awakening upon a moor to see a fine, if rather ghostly, horse galloping towards him. The theme, which refers to the state of the blessed – 'And there shall be no night there' – as told to St John, is taken from the last book in the Bible, Revelation (22:5) and may, as Hilary Pyle suggests, have been a passage read at Cottie's funeral. Yeats' use of a text, as here, to amplify his feelings is common in his work. The scene is not apocalyptic, of course, but nevertheless the autobiographical nuances cannot be mistaken.

The theme of the horse permeates the whole of Yeats' *œuvre*: horses are second only to people in his work and whenever they appear they carry – to a greater or lesser degree – an aura of dignity, energy and strength. Their presence is always enriching, from early works like *Before the Start* (1915) to the supplication of *Come* (1950) and the devotion of *My Beautiful, My Beautiful* (1953). More specifically, the white horse in *There is No Night* has reverberations in Revelation (19:11) – 'And I saw heaven opened, and behold a white horse; and he that sat upon him *was* called Faithful and True' – and thus, with its implied steadfastness, it evokes the source of the artist's optimism. The imagery here is also typical of much of Yeats' work, the warm earthy tones of the landscape and the symbolic brightening of the sky announcing the traveller's arrival in some promised land.

Technically in this work, as in *Homage to Bret Harte* (1943) and *Glory to the Brave Singer* (1950), we see Yeats at the height of his powers, the fluency of his brushwork and bold use of colours being perfectly suited to his mood, while the imagery, with its suggestion of man's association with 'a spirit of place', lends a universal feeling to the whole.

1949
OIL ON CANVAS (101.5 x 152.5 CM / 40 x 60 IN.)
HUGH LANE MUNICIPAL GALLERY OF MODERN ART, DUBLIN

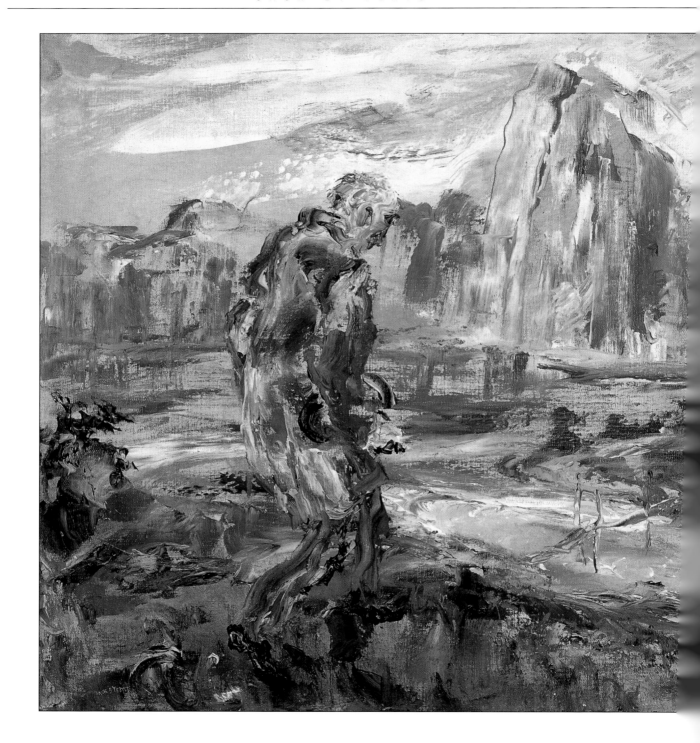

ON THROUGH THE SILENT LANDS

This is a fine example of Yeats' late work, the subject-matter, with its sense of the universal, recalling the 'human condition'. 'What and where are the Silent Lands?', one might ask. Are they 'silent' because, at the end of our lives, the world has little to offer us? Is this a depiction of loneliness? Does one cross the bridge to death and the lands of ultimate silence? Alternately, perhaps this terrain represents the inner world of dreams in which we all take refuge. Yet, paradoxically, as Surrealism tells us, this dream world is often more real than the apparent reality of things seen. What too, one might ask, is the figure in the composition doing? Is he trudging across this hostile landscape bowed and broken, or, rather, might he be rising phoenix-like from it?

We can never answer these questions, but can only speculate that for Yeats the picture, painted near the end of his life and with his wife dead, stood as a metaphor for the ephemeral nature of our existence. Or perhaps, more broadly viewed, as in the words of an early critic of the artist, Thomas MacGreevy, 'Yeats' work at this time became a passionate recall to poetry – to the splendour of essential truth'.

1951
OIL ON CANVAS (51 x 68.5 CM / 20 x 27 IN.)
ULSTER MUSEUM, BELFAST

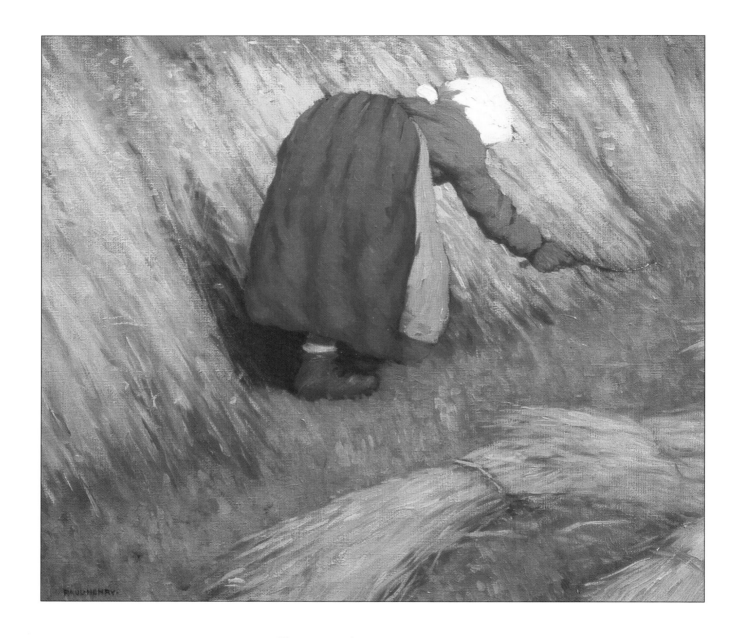

WOMAN CUTTING RYE
1912-13
OIL ON CANVAS (34.3 x 39.4 CM / 13^1/$_2$ x 15^1/$_2$ IN.)
PRIVATE COLLECTION

Paul Henry

Paul Henry grew up in a strict evangelical household in *fin de siècle* Belfast. His father was a clergyman who, having ministered to a number of denominations, renounced them all to pursue his own path in life. The narrowness of his upbringing was to colour Paul Henry's outlook throughout his career, despite his efforts to escape it.

On leaving school in 1893 Paul Henry was apprenticed as a damask designer with the Broadway Damask Company, but soon gave that up to enrol as a student at the Belfast School of Art. There he was idyllically happy and won a number of prizes. In the autumn of 1898, with the financial backing of a relative, he went to Paris where, for the next two years, he studied at the Académie Julian, at Whistler's Académie Carmen, and at other ateliers. Paris was the city of Henry's dreams and, as he later recorded, was a turning point in his life. There he first encountered modern art, in particular Van Gogh, Gauguin, Cézanne and, of course, Whistler himself, who was to have a lasting influence on him. In Paris he also met Grace Mitchell who later became his first wife.

In 1900, with his money running out, Henry moved from Paris to London to work as an illustrator. There he encountered Robert Lynd, an old school friend who was working in London as a journalist. He also met Ladbroke Black, whom he had known in Paris, and who, as editor of the journal *To-day* subsequently put much work his direction. In 1903 Grace and he, now married, moved to Surrey and Paul began to paint and to exhibit his work in some of the London galleries. Despite a promising career, in 1910, on the advice of Robert Lynd, the Henrys went to Achill Island, off the west coast of Ireland, where they eventually settled for the next nine years.

Achill was to be the dominant experience in Paul Henry's life. In the local peasantry and the landscape of the West he found subject-matter which excited him and which he treated in a manner which was new to Irish painting. He remained on Achill until 1919, before settling in Dublin for the coming decade. There for a time he identified himself with the avant-garde and in 1920 instigated, with Jack B. Yeats and others, the foundation of the Society of Dublin Painters, who were to represent the most advanced artists in Ireland until the 1940s. By that time Henry was regarded as the most innovative and important Irish landscape painter of his generation.

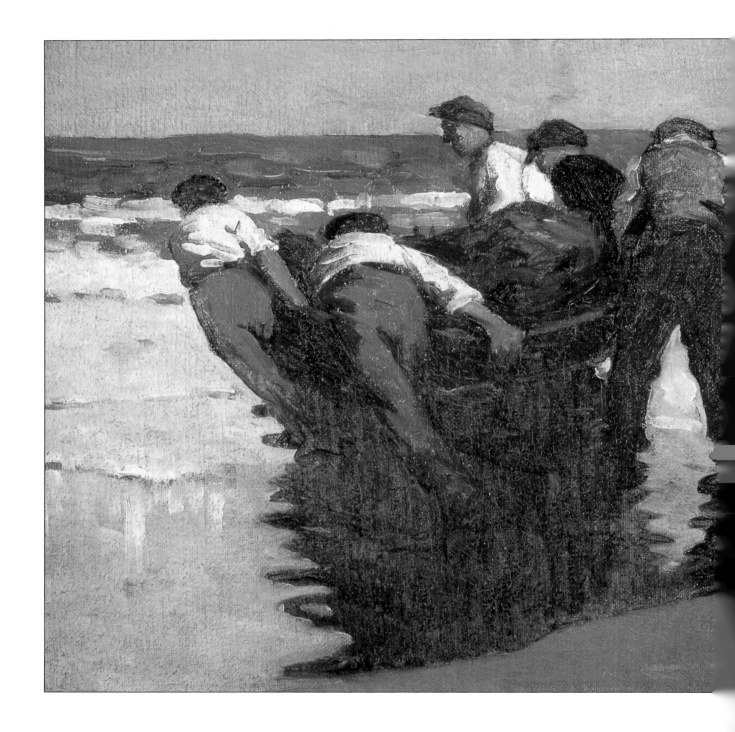

LAUNCHING THE CURRAGH

This is one of Paul Henry's finest figure paintings. As is characteristic of his work done shortly after he settled on Achill Island, the composition is succinct, the forms of the figures are painted without any detailing, the essence of the composition being concentrated on the effort of the men as they strain to drag the little craft – which is almost imperceptible – into the sea.

As with the composition the range of colours too, is limited, and visually, the men's white shirts as they thrust forward connect with the surf of the breakers and hint at the drama which lies ahead. The paint has been applied virtually as a stain on the canvas and only on the highlighted areas and in the sea is there any notable impasto.

Fishing was an important part of the economy of Achill when Henry lived there. As he noted in his autobiography, *An Irish Portrait* (1951), the curragh was the ideal craft for fishing as it was light, easily moved and required no harbours. But fishing was dangerous and the islanders treated the sea with great respect. Women never went out in the boats because it was considered unlucky, wrote Henry, and, he said, it was common for women to turn aside so as not to meet a man if he were going fishing.

1910-11
OIL ON CANVAS (40 x 60CM / 16 x 24 IN.)
NATIONAL GALLERY OF IRELAND, DUBLIN

THE POTATO DIGGER

This picture was painted shortly after Paul Henry first settled on Achill Island. The theme, the harshness of life for the peasant farmers there, was to preoccupy him for the first three or four years of his stay. 'I have yet to see people who worked so hard for so little gain … incessant toil with the spade; ploughs [being] useless on … these stony fields', he later wrote in *An Irish Portrait*. The stance of the figure leaning against a spade, her expression of pathos and her red flannel dress are characteristics of a number of Henry's compositions of potato diggers and in this case closely resemble the standing figure in the celebrated *Potato Diggers* composition, of 1912, which is now in the National Gallery of Ireland. The handling of paint, which has been applied with careful deliberation and small strokes of the brush to define the forms, is quite characteristic of Henry's work from this time.

Henry first visited Achill for a holiday in the summer of 1910; he was enthralled with the place and shortly afterwards decided to settle there. 'Achill spoke to me, it called to me as no other place had ever done', he later wrote in his autobiography. He continued: 'The desire to live in Achill was a purely emotional one. I wanted to live there, not as a visitor but to identify myself with its life and to see it every day in all its moods … I wanted to know the people, their intimate lives, the times of seed-time and harvest. Only after I had gained such knowledge would I be able to paint the country which I had adopted'. The women in particular made a deep impression on Henry. Red homespun flannel, he tells us, was almost universally worn by the older women at that time. 'This coarse material … after wear and weather and washing, turned to a variety of tones, and a group of women working in the fields with a background of rich brown earth, made the strip of earth they were working on a riot of gay colour', features which clearly influenced this picture. But amongst the islanders Henry encountered one of the oldest of human superstitions, namely the belief that in drawing them something of the subject entered into the drawing; thus much of his figure work had to be done surreptitiously and, one suspects, the woman depicted here was almost certainly done from sketches made covertly.

The compositional technique used here, namely a low horizon and a heavily clouded sky, the two elements being united by the upward thrust of (in this case) a figure is a device common to Henry's work.

1912-15
OIL ON CANVAS (36 x 46 CM / 14$^1/_8$ x 18$^1/_8$ IN.)
ULSTER MUSEUM, BELFAST

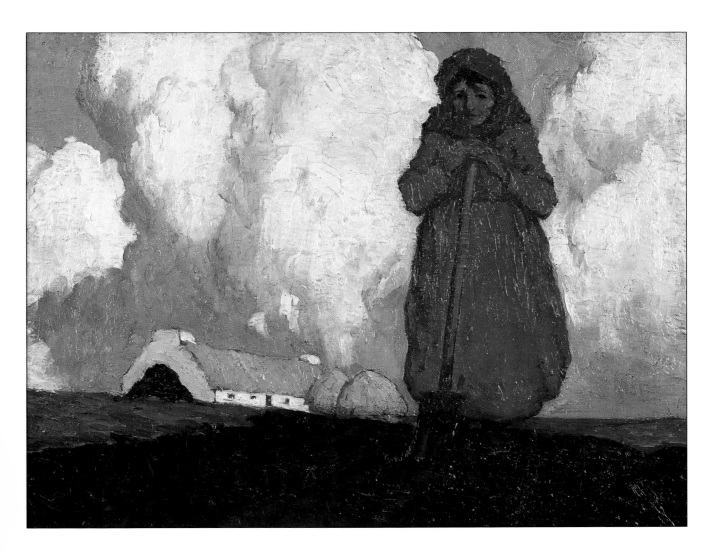

KILLARY BAY, CONNEMARA

This is one of Paul Henry's few dated works and an excellent example of his early Achill period. When he first went to Achill Henry was moved by the hard life of the peasantry there in their unequal struggle against the forces of nature. His first Achill pictures were thus dominated by figures and depicted peasant farmers at work digging potatoes, cutting rye, bringing home turf, fishing or harvesting seaweed. Only occasionally, as in *Old People Watching a Dance* (c. 1910-11), do we see them relaxing. Thus these early works have an almost anthropological import and it was only later that the actual landscape came to dominate his *œuvre*. From about 1913, however, he began to explore painting the landscape itself, often devoid of people, concentrating rather on the mood and atmosphere of the scene.

This picture is one of Henry's first 'pure' landscapes and in it one can see a number of attributes which became characteristic of his work in general: a sense of stillness, a summary rendering of masses, the use of only a few colours, all features which combine to produce a semi-abstract underlay to the composition. In this respect the treatment of the landscape here is similar to that in other of Henry's mature works, such as *Dawn, Killary Harbour* (q.v.), of about 1921 (Ulster Museum).

Paul Henry liked to paint in the early morning, savouring what he called the 'otherworldliness' and 'sense of mystery' in the Irish landscape, and no doubt the cool morning light contributed to the gentle modulation of tones which we see here. This picture may have been exhibited in Henry's joint show with his first wife, Grace, at Pollock's Gallery, Belfast, early in 1913. Writing in the foreword to the catalogue of that show the critic Frank Rutter, whom Henry had known in London, commented: 'Mr Henry has given us many charming landscapes of French and English scenery, but his native isle has stirred deeper emotions which he is able to reconvey to the spectator with a force and conviction never equalled in his previous work'.

The economy of means here, the muted colours save for the pungent yellow of the gorse in the foreground, the sense of isolation and stillness with yet the whole image redolent of human presence are surely the qualities that Rutter perceived; this ability to express the universality of our relationship to the landscape is, perhaps, Henry's finest achievement.

1913
OIL ON CANVAS (67 x 79 CM / 26^1/$_2$ x 31 IN.)
PRIVATE COLLECTION

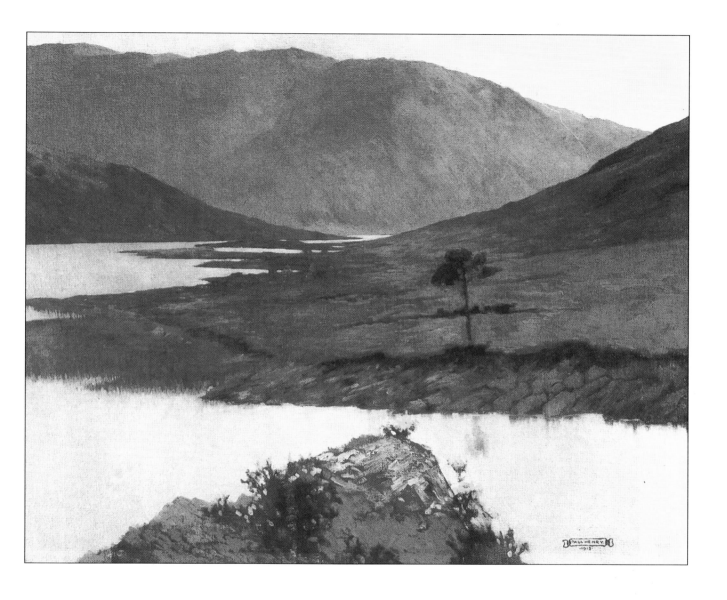

DAWN, KILLARY HARBOUR

This is arguably Paul Henry's masterpiece. Its simplicity of concept and execution, however, betray a very skilful hand at work. Characteristically, there is a complete absence of people, yet a redolence of humanity; a strong sense of early morning light and atmosphere; and, in the simple massing of forms and almost monochromatic palette, an emphasis on abstraction underpinning the composition. The latter quality demonstrates the influence of Whistler, which dominated Henry's early illustration work done in London in the first decade of the century, before giving way to Millet when he went to Achill Island. However, Whistler's influence returned forcefully in the early 1920s when this and one or two related pictures were painted.

Henry greatly admired Whistler who, in terms of technique, was the most important influence on his development as an artist. Above all, from Whistler he learnt to observe things in simple, direct terms and to set them down harmoniously in closely modulated tones. 'You must see your picture on the palette', he would tell his students. 'Here, not on your canvas, is your field of experiment, the place where you make your choices'. Whistler emphasized a methodical approach to painting. 'You *must* know how you did it, so that you can do it again', he would say. 'Remember which of the colours you employed, how you managed the turning of the shadow into the light, and if you do not remember, scrape out your work and do it all over again … You must be able to do every part equally well, for the greatness of a work of art lies in the perfect harmony of the whole, not in the fine painting of one or more details'. But despite his admiration for Whistler, Henry became critical of his instruction, noting later in life that 'his influence was so strong that we were all painting dreary vague abstractions directly inspired by the master'.

Paul Henry liked to paint in the early mornings when all was still and the light cool and soft. This, no doubt, influenced his choice of muted colours and subdued tones, which are clearly evident here, although his red-green colour blindness must also have influenced his palette. Henry was greatly drawn to what he called 'the mystery of dawn', which he thought was the 'most perfect' part of the day. 'I had generally done a good day's work before the first smoke went up from the cottage chimneys', he wrote in *An Irish Portrait*.

With Henry and some of his contemporaries, such as Jack B. Yeats, the landscape as *place* and the lives of the people who worked it became an overriding concern for the first time in Irish painting, fostering a popular view of the West that was to have lasting socio-economic and political implications.

1921
OIL ON CANVAS (69.1 x 83.3 CM / 27 x 33 IN.)
ULSTER MUSEUM, BELFAST

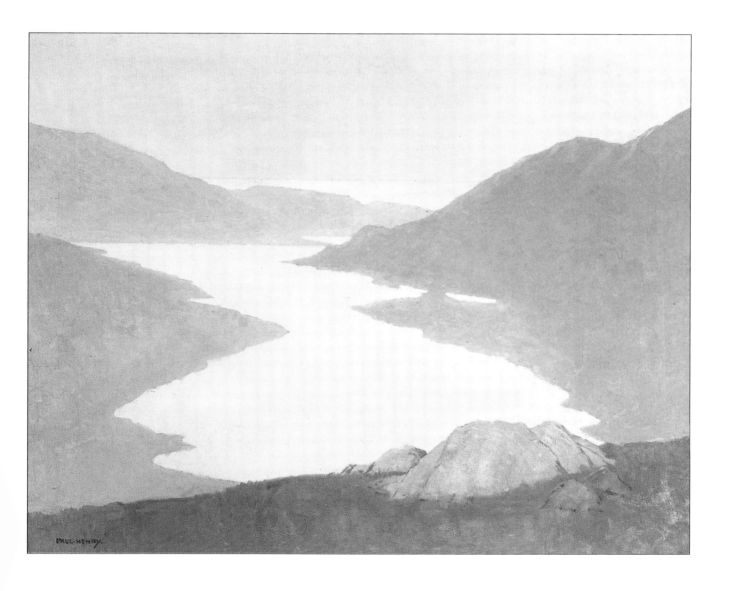

LAKESIDE COTTAGES

This picture represents the full maturity of Paul Henry's art. When he first settled in Ireland Henry busied himself painting scenes of figures toiling in the fields which, although they were rooted in the landscape of the West, were much influenced by the French painter Millet; later the influence of Whistler predominated, but from the early 1920s he gradually developed a style which was completely his own and which was unmistakably indigenous to Connemara. *Lakeside Cottages* is one such work and may be regarded as the quintessential 'Paul Henry'. In his handling of the billowing cumulus clouds, the soft terrain of the bog and the whole way of life suggested by the thatched cottages, each with its turf stack for fuel, Henry produced a degree of Realism which was new to Irish painting. There is here an overpowering sense of stillness and timelessness, though the depiction of such crofts echoes a way of life that has now virtually disappeared from Ireland.

Technically we have here the pinnacle of Henry's achievement, the culmination of all that he strove for previously. Henceforth, alas, in the following decades his work too often devolved to a cliché of this.

1929-32
OIL ON CANVAS (40 x 60 CM / 16 x 24 IN.)
HUGH LANE MUNICIPAL GALLERY OF MODERN ART, DUBLIN

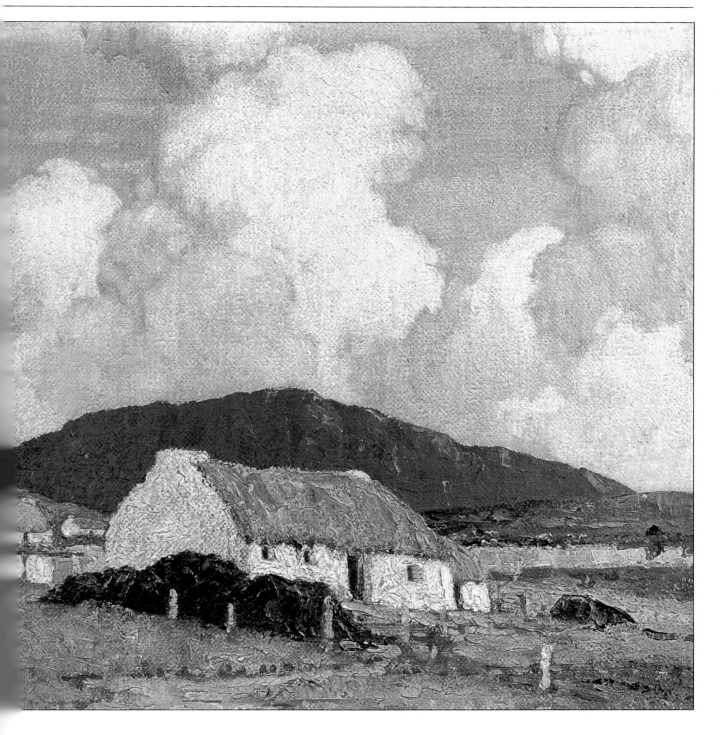

Sir William Orpen

Sir William Orpen was one of the most talented and celebrated Irish artists of his generation. Principally a painter of portraits and genre scenes, he had an enormous – some say overwhelming – influence on Irish painting in the early decades of the twentieth century. Orpen began his career as a student in 1891 at the Metropolitan School of Art, Dublin, but in 1897 went to the Slade School, London, where he subsequently won both the celebrated Life Painting and Composition prizes. On leaving the Slade in 1899 he exhibited at the New English Art Club, a group which was then the spearhead of the English avant-garde, and became a member in 1900. He held his first one-man exhibition at the Carfax Gallery, London, in 1901. Although he lived in London, from 1902 till 1914 Orpen visited Dublin regularly, teaching for part of each year at the Metropolitan School, where he greatly influenced a generation of Irish painters such as Margaret Clarke (1888-1961), Sean Keating (q.v.), James Sleator (1885-1950) and Leo Whelan (1892-1956). With Augustus John, who had been his contemporary at the Slade, he ran the Chelsea Art School from 1903 till 1905.

Orpen's celebrity as an artist brought him many honours. He was elected an associate member of the Royal Hibernian Academy in 1904 and a full member in 1907, and was similarly elected to the Royal Academy in 1910 and 1921 respectively. During the First World War he was an Official War Artist in France, an experience which had a profound effect on him. Soon after his return he offered all his paintings and drawings from that period to the Imperial War Museum, an act which caught the public imagination at the time and which derived, in Bruce Arnold's words 'from [a] deep conviction and involvement in the war.'

Orpen was knighted in 1918 and the following year was an official artist at the Paris Peace Conference. In 1921 he was elected President of the International Society of Sculptors, Painters and Gravers (he had been a member since 1907), and that same year published his experiences of the war as *An Onlooker in France*, and, in 1924, this was followed by *Stories of Old Ireland and Myself*. A memorial exhibition of his work was held at the Royal Academy in 1933. Sir William Orpen, in Kenneth McConkey's words, was 'the essential Edwardian painter'.

RESTING
1905
OIL ON CANVAS (76.2 x 55.6 CM / 30 x 22 IN.)
ULSTER MUSEUM, BELFAST

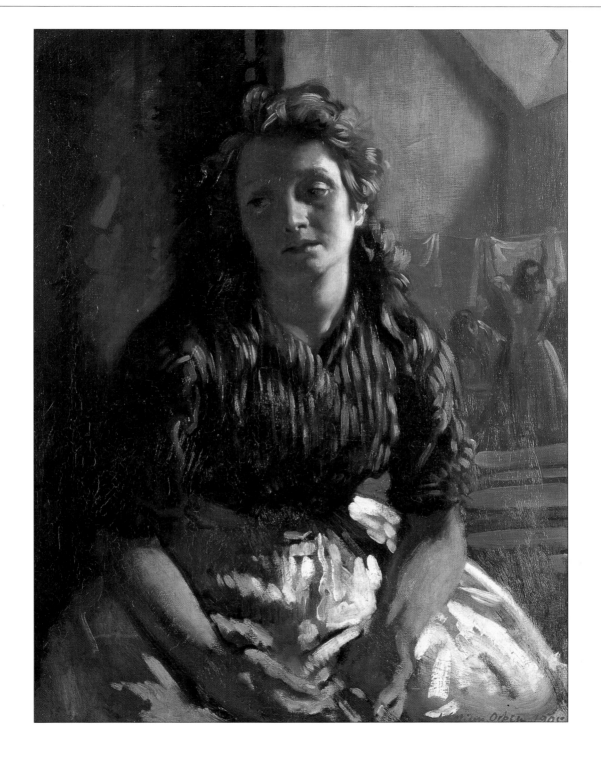

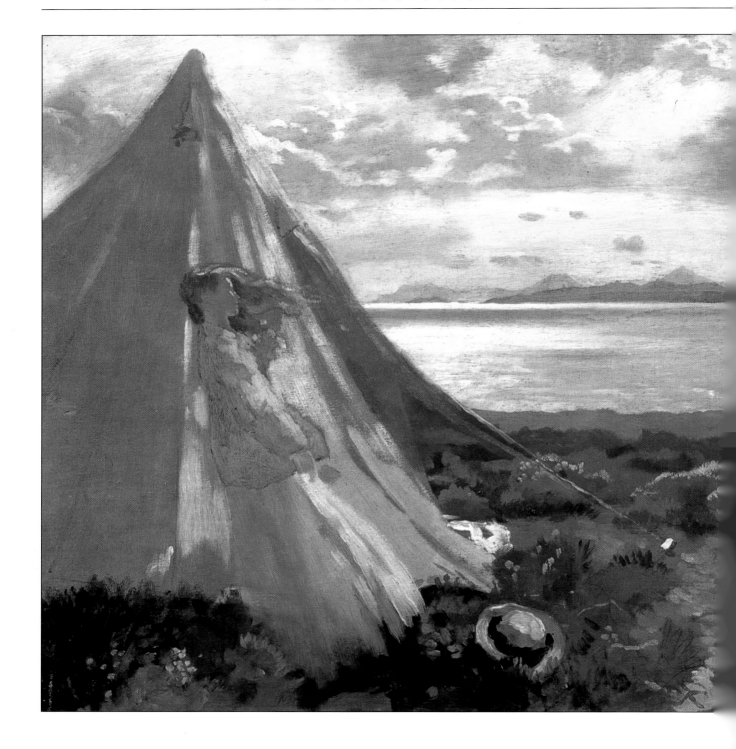

A BREEZY DAY,
HOWTH

One of Orpen's former pupils, Sean Keating (q.v.) idolized the artist for his talent, and shortly after his death wrote a eulogy to him, which describes his method of working concisely. 'What he observed,' he said, 'seemed to go in through his eyes, be analyzed and arranged by his brain, and written down with the inevitable rightness by his unerring hand, as one complicated movement of his will'. He continued, 'He painted at an incredible speed without alteration or erasures, and then, if it was not exactly what he wanted, he simply wiped it out and began again – but that was seldom'. This, said Keating, was the secret of his freshness and clarity of colour. Orpen 'loved paint itself', and would say, 'Wouldn't you like to eat it?' And he concluded: 'He taught that sufficient paint to create the illusion of light and shade, of tone and colour was enough, and laughed at "touch", "impasto" … and, to use his own words, "all that sort of tosh"'.

A Breezy Day, Howth is one of a series of *plein air* pictures executed in the years prior to the First World War and illustrates Keating's comments. The composition is direct in concept, the palette is 'clean', the brushwork spontaneous and assured and the freshness of the breeze blowing off the sea permeates the whole scene.

1909-13
OIL ON CANVAS (39.3 x 59.7 CM / 15$^1/_2$ x 23$^1/_2$ IN.)
HUGH LANE MUNICIPAL GALLERY OF MODERN ART, DUBLIN

The Roscommon Dragoon

In the years immediately before the First World War Orpen quickly made a reputation for himself as a portrait painter, a genre to which he was to devote himself almost exclusively after the war. Most of his portraits, however, were done to commission and, over the years, he grew tired of the drudgery of such work. But from time to time, and particularly before the outbreak of war in 1914, he painted for his own pleasure a number of portraits which are amongst his best ever paintings of any kind. His portrait of Vera Hone, known as *The Roscommon Dragoon*, is one of six studies he made of Mrs Hone in the years between 1911 and 1913. Others include *The Chinese Shawl* (1911), *The Blue Hat* and *The Angler*, both 1912, and *The Irish Volunteer* (1913), another military piece. Of these, perhaps *The Blue Hat* could be put against *The Roscommon Dragoon*, as the most striking of these works.

Vera Hone (née Brewster) was an American beauty. In 1911 she married Joseph Hone, later to be the biographer of George Moore, Henry Tonks and W.B. Yeats, and she and her husband settled in a house beside the Orpens in London. She was greatly admired by Orpen and many others and, Sean Keating tells us, was known as 'the lovely Vera'. However, in 1913 she and her husband moved to Dublin where Joseph Hone settled into a literary career and her time as the artist's model was over.

Vera Hone is depicted in this arresting portrait dressed in an infantry tunic of the mid-nineteenth century and in her hand she holds a shako of the Roscommon militia of the same period. It is from this uniform that the portrait takes its title. In Bruce Arnold's words, Vera Hone was 'without question' the most beautiful woman Orpen ever painted, her deep blue eyes, golden hair, almond-shaped face and full mouth giving her an alluring presence. As in all of Orpen's portraits of her, her personality fills the canvas with life, and his sensitivity to her character, expression and attire are conveyed with a Romantic lyricism which, given Irish political sensibilities at the time, that is, the period immediately preceding the Easter Rising of 1916, would have had an immediate resonance for contemporary viewers.

The Roscommon Dragoon quickly became one of Orpen's most celebrated works and in the years after the First World War it was published as an early colour collotype and was widely distributed. A daughter of a friend of Orpen's, Vivien St George – herself destined to be painted by the artist – commented justifiably of its sitter: 'Were there an "Orpen type" she'd be it'.

1913
Oil on canvas (76 x 63.5 cm / 30 x 25 in.)
Private Collection

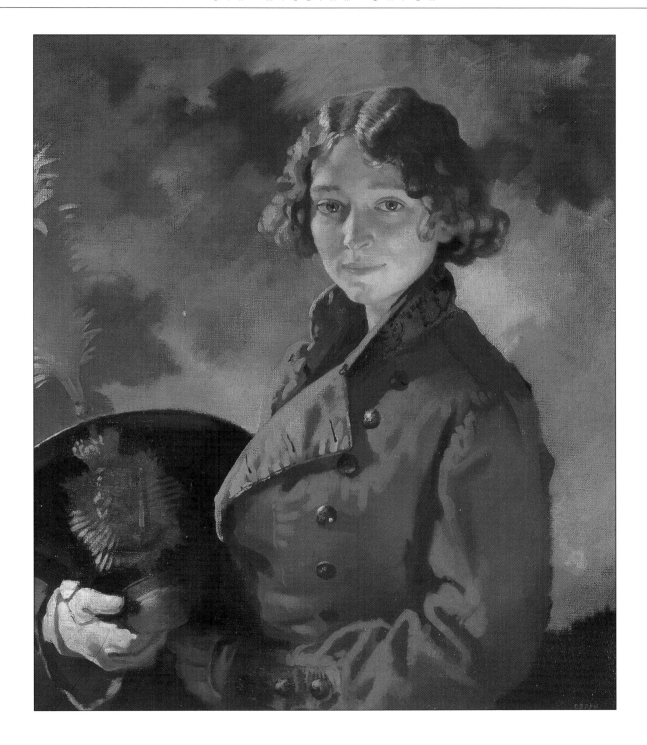

L ADY E VELYN H ERBERT

This study of Lady Evelyn Herbert shows Orpen at the height of his powers as a portraitist. Despite it almost certainly having been a commissioned work, he delights in dazzling us with his virtuosity and sheer exuberance in handling oil paint. Lady Evelyn Herbert was the only daughter of George Edward Stanhope Molyneux Herbert, fifth Earl of Carnarvon, of Highclere Castle, near Newbury, an eminent Egyptologist, who in November 1922 discovered the tomb of Tutankhamun. Lady Evelyn was with her father on that expedition and was one of the first people to enter the tomb. Her grandfather, the fourth Earl of Carnarvon, was lord-lieutenant of Ireland in 1885 and 1886.

By the time he embarked upon this work Orpen was already regarded as one of the most celebrated portraitists of his time. His first biographers, P.G. Konody and Sidney Dark, in *Sir William Orpen, Artist and Man,* described his technique in portraiture in a manner which is clearly to be seen in this picture: 'His early-acquired complete command of draughtsmanship and understanding of the human frame made him, in the years of his maturity, dispense with "drawing" in the narrower sense of the word. That is to say, his method of painting came to have a closer affinity to the sculptor's method of building up his forms with little lumps of clay by pressure of the thumb, than to that of the draughtsman who obtains structural emphasis by linear definition. Many of his later pictures, when viewed closely, appear to be built up of fuzzy-edged touches of solid colour, applied with a round brush. The forms grow out of the paint without any clearly marked contour, without any apparent scaffolding of linear drawing'.

The pose of the Lady Evelyn Herbert portrait is similar to that in Orpen's study *Lily Carstairs*, painted a year earlier. In each case we are brought face to face with the sitter, there being no indication of context or setting to distract our attention. The appeal of the Herbert portrait, however, undoubtedly lies in the coy expression worn by the sitter, her reticence contrasting with the flamboyance of the execution. As Konody and Dark observed, Orpen here has made extensive use of a round brush, which differentiates the resulting effect from the flatness associated with the use of a square-cut or flat brush, preferred by many artists of the period. Thus, for example, in Lady Herbert's face he has been able to model the features with great subtlety, one form gently giving way to another, while in his treatment of her hair and, to a lesser extent, in her dress, the brush strokes have been used expressively to suggest not only form and shape but vigour, energy and a suggestion of devil-may-care abandon.

1915
O IL ON CANVAS (76.2 x 63.5 CM / 30 x 25 IN.)
P RIVATE C OLLECTION

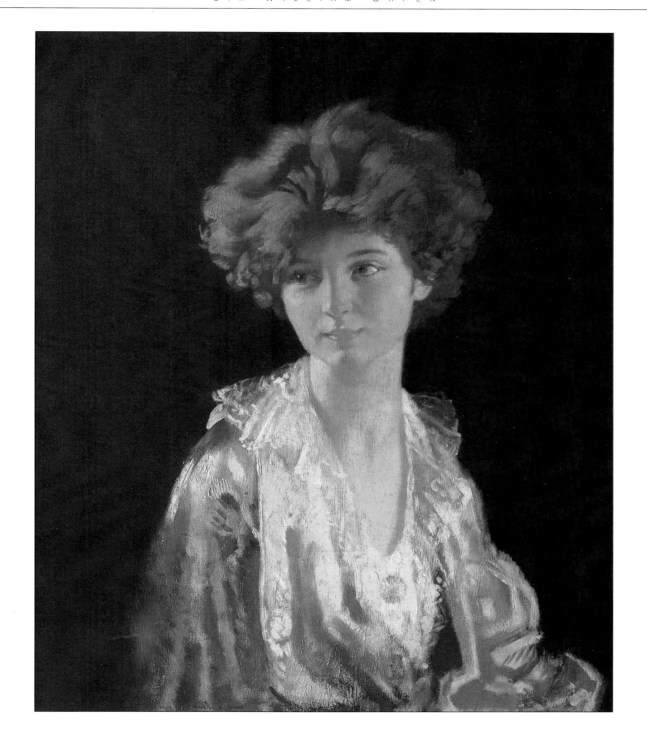

THE THINKER ON THE BUTTE DE WARLENCOURT

When war broke out in August 1914 Orpen was in Ireland. Like many people at the time, he believed the hostilities would be ended by the following Christmas and that events would not greatly affect him. But that was not to be so. In 1916 he was enlisted in the army and in the spring of 1917 went to France, to the Somme, as a war artist, his orders being to record events as he saw them. His experiences would alter his values forever.

To begin with Orpen was impressed by the scale of the operations in France and the bravery and sacrifice which were all around him. 'The whole thing is pure, noble and bold', he wrote home. But before long he was overwhelmed by the appalling waste and tragedy of those events as well as by the insensitivity of many of those in charge. As a war artist Orpen needed solitude and time to think. In a letter to Henry Tonks he spoke of the war artist scheme in general, saying he felt that too many artists saw the war as something to be observed; for him, on the other hand, it was a deeply emotional experience.

During the long hot summer of 1917, besides numerous drawings and watercolours, Orpen made several major oil paintings of the Somme battlefields. These paintings include *The Butte de Warlencourt*, a poignant study of a piece of high ground near the village of Le Sars which had seen some of the heaviest fighting of the campaign and which changed sides often. By the time Orpen got there, however, it was in Allied hands. *The Thinker on the Butte de Warlencourt*, later worked up from a drawing made at that time, is one of his most thoughtfully provocative and moving war pictures – in it he questions the whole nature of the war, its morality, purpose and cost. The composition is derived from Rodin's celebrated sculpture *The Thinker*, with its brooding colossus, but Orpen portrays an ordinary soldier who has stopped to ponder the cost in lost lives of gaining the small hillock upon which he is now in command.

This lone infantryman sits upon the chalky mud turned by the sun to a snowy whiteness. The drama of the scene is formed by the contrast between the man's self-contained pensiveness and the dramatic dark blues and unnatural reds and greens of the sky, the latter inflamed by the heat of battle, and is heightened by the almost surreal light which catches the figure and the foreground. Here is an unreal world, yet amid such circumstances Orpen was often fascinated by the contrasts between man's brutality and nature's benevolence. In Bruce Arnold's words, at such times 'the evidence of death was all around him, but so was the evidence of life. Skulls and flowers were side by side'.

1918-19
OIL ON CANVAS (91.5 X 76 CM / 36 X 30 IN.)
PYMS GALLERY, LONDON

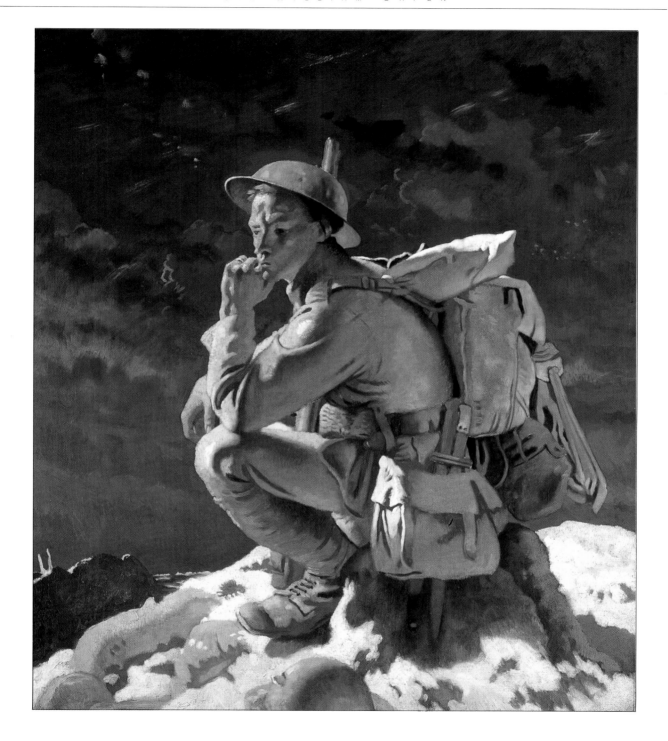

SUNLIGHT

'Can a nude ever go well … I spent the afternoon in the Louvre looking at Nudes and there are none in the least like a woman', Orpen wrote to his friend William Rothenstein in 1921. Although Orpen painted many nudes – *The Model* (1911), *The Disappointing Letter* and *Early Morning*, both 1922, are good examples – as Bruce Arnold has noted, often in these works the woman's nudity 'is incidental', the real subject-matter lying in the narrative element of the scene. Perhaps it was Orpen's frequent interest in an underlying narrative which gave him difficulty with the nude as a genre. The narrative element – reading a letter, pulling on stockings, for example – is usually passive, but nevertheless intrudes between us and the nude herself. This is certainly the case in *Sunlight*.

P.G. Konody and Sidney Dark in their celebrated biography of Orpen, published shortly after the artist's death, note that for relaxation from the daily round of portraiture he enjoyed painting 'complicated effects of brilliant sunlight … superimposing a shifting geometric pattern of light and shade upon the permanent pattern formed by the objects and posing model'. They continued, 'The problem offered by the struggle between unsubstantial geometric shadow picture and the permanent form which constitutes, as it were, its canvas, never ceased to fascinate an artist who always had an eye for bizarre effects'. *Sunlight*, said Konody and Dark, was one of the most notable pictures of this type, Orpen working free from all restraint, 'displaying all his virtuosity and an almost feverish vivacity'.

Here is an apparently simple composition: a young woman seated on a sofa, parallel to the picture plane, pulls on her stockings. The room is flooded with sunlight and there is elegance in the décor and furnishings (indeed, a Monet owned by Orpen hangs on the wall behind). To the left a window directs the light which falls diagonally across the scene in such a way that the figure is partly silhouetted against it. The movement of the figure, as she leans forward, emphasizes the diagonal thrust of the light and brings a degree of drama to the scene. Throughout there is much emphasis on brushwork and the act of painting, which is demonstrative rather than passive, on colour and the use of complementary hues in the dark shadows, on light *per se*. All these things indicate that Orpen, though principally an academic painter, had a keen awareness of some of the issues with which the more avant-garde artists of the day wrestled. *Sunlight* is a *tour de force*, an expression of pure joy.

C. 1925
OIL ON PANEL (50.7 X 61 CM / 20 X 24 IN.)
NATIONAL GALLERY OF IRELAND, DUBLIN

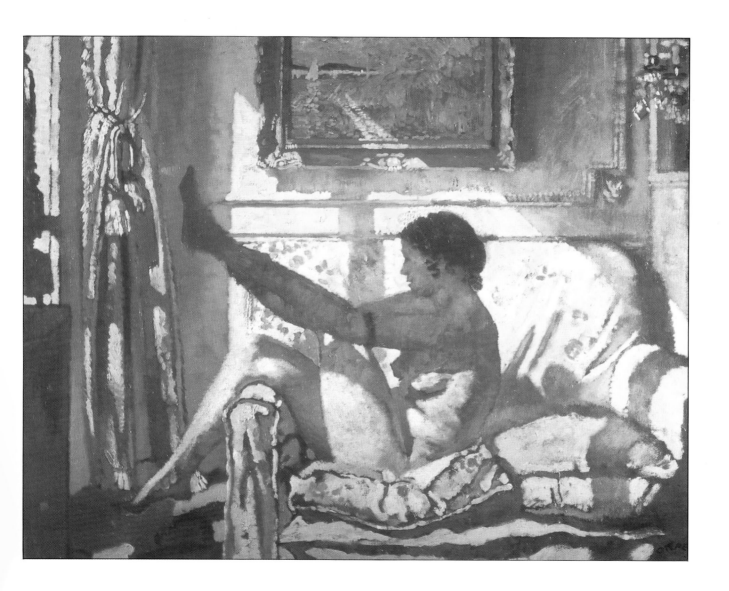

William John Leech

The landscape and portrait painter William John Leech was educated privately and at St Columba's College, Rathfarnham, before going, in 1900, to the Metropolitan School of Art, Dublin, and the following year, to the Royal Hibernian Academy Schools where he studied under Walter Osborne. In 1901 he enrolled at the Académie Julian in Paris as a pupil of the once celebrated Adolphe Bouguereau and remained there for two years; during this time he also took lessons at the studio of Jean Paul Laurens (1838-1921). Thereafter, until 1917, he lived largely at Concarneau in Brittany, although he often made visits home and exhibited regularly in Dublin, both at the Royal Hibernian Academy and in the company of George Russell (Æ), Dermod O'Brien (1865-1945) and other of his contemporaries. He was elected an associate of the RHA in 1907 and a full member in 1910. In the latter year his parents had moved from Dublin to London and Leech henceforth divided his time between France and England. In 1912, in London, he married Saurin Elizabeth Kerlin, but they separated after a few years. In 1914 he was award a bronze medal at the Paris Salon. Having subsequently returned to England he became eligible for military service and in 1918, in the closing stages of the First World War, was called into the army and served for a time in France.

Throughout these years, even during the war, he continued to exhibit annually at the Royal Hibernian Academy and, from time to time, he also showed at the New English Art Club and at the Royal Academy in London. Yet the war made a deep impression on him and for a while he suffered from depression. In 1919 he met May Botterell, the wife of a distinguished London lawyer, and they formed a close relationship, she supporting him both emotionally and financially. But the clandestine nature of their relationship meant that Leech had to keep out of the limelight and hence it curtailed his exhibiting, especially in London. It was not until 1952, when Mrs Botterell's husband died, that she and Leech were able to marry; they settled in Cobham near Guildford in Surrey. In 1944 Leech met Leo Smith of the Dawson Gallery, Dublin, and Smith subsequently became his agent. In 1965 May Leech died and three years later Leech himself died after falling from a railway bridge near his home.

Although Leech was one of the most avant-garde Irish painters of his generation, his absence abroad meant that he had less influence on artists in Ireland than his stature might otherwise suggest.

ALOES
c. 1922
OIL ON CANVAS (181 x 148.3 CM / 71^{1}/$_{2}$ x 58 IN.) ULSTER MUSEUM, BELFAST

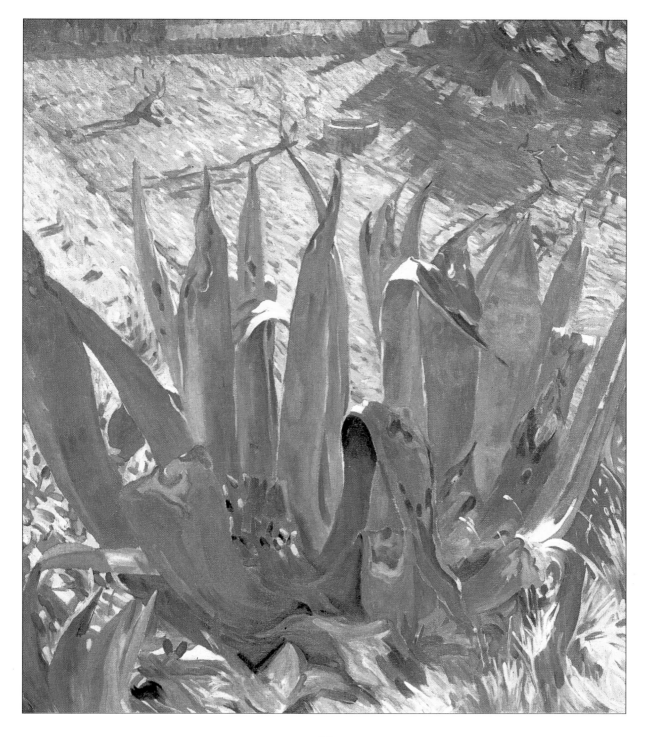

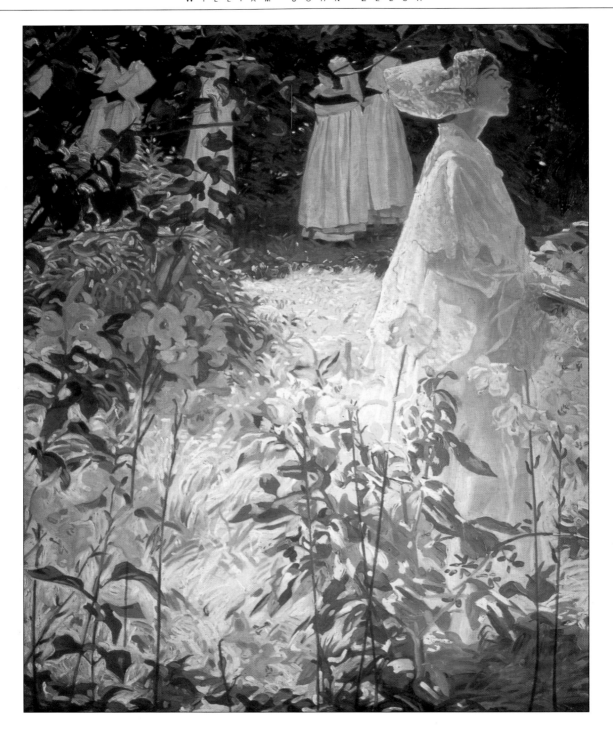

A CONVENT GARDEN, BRITTANY

Leech's early paintings, as one would expect from an artist of his training – Osborne taught me 'all I need to know', he once said – were somewhat formal, but in time, notably after the influence of Post-Impressionism, which he experienced at first hand in France, his work became more fluid. From the early 1920s his sense of colour, too, became more subtle and acute and in many ways colour and the manipulation of light might be said to be the real subject-matter of his art.

In the distribution of light and shade *A Convent Garden, Brittany* still betrays some of the formality of Leech's early work, done before he went to Brittany, although the mood of the scene is now lighter than before and a broad painterly style is evident. The composition is almost identical to that in *The Secret Garden* which, presumably, was painted just before it, and which, in Denise Ferran's phrase, is most likely 'a recapturing' of the garden at the hospital and convent of the Sisters of the Holy Ghost in Concarneau where Leech recuperated after a bout of typhoid fever in 1904. The picture is therefore partly autobiographical. But it is also a soliloquy, the artist anticipating his forthcoming marriage, his bride-to-be being the model for the main figure. Dressed in customary Breton bridal costume, she is compared to a novice of the church about to enter into a lifetime's commitment; but as she had a previous marriage and was now divorced such a traditional ceremony would not take place on this occasion (they were, in fact, married in a registry office).

The splendour of *A Convent Garden*, however, derives from the boldness of placing the main figure to the right of centre, and about to exit the picture, and the evocation of tranquillity and contemplation which are the dominant themes in it. Besides the theatricality of the pose and the manipulation of light and shade, the vigour of the brushwork, which owes much to Van Gogh and Post-Impressionism, dominates our attention and subsequent reading of the surface, which, despite the over-riding theme, provokes a sense of restlessness, which is emphasized by the movement of the flowers in the foreground. Indeed, as Julian Campbell has noted, there is too a disharmony between the whites and greens, and even the warm yellows and cool greens and blues of the shadows seem a little uneasy. Perhaps Leech himself was ill at ease for sadly his marriage was to last only a few years, although after it ended he and his wife (they were never divorced; she died in 1951) remained good friends.

c. 1911-12
OIL ON CANVAS (132 x 106 CM / 52 x 42 IN.)
NATIONAL GALLERY OF IRELAND, DUBLIN

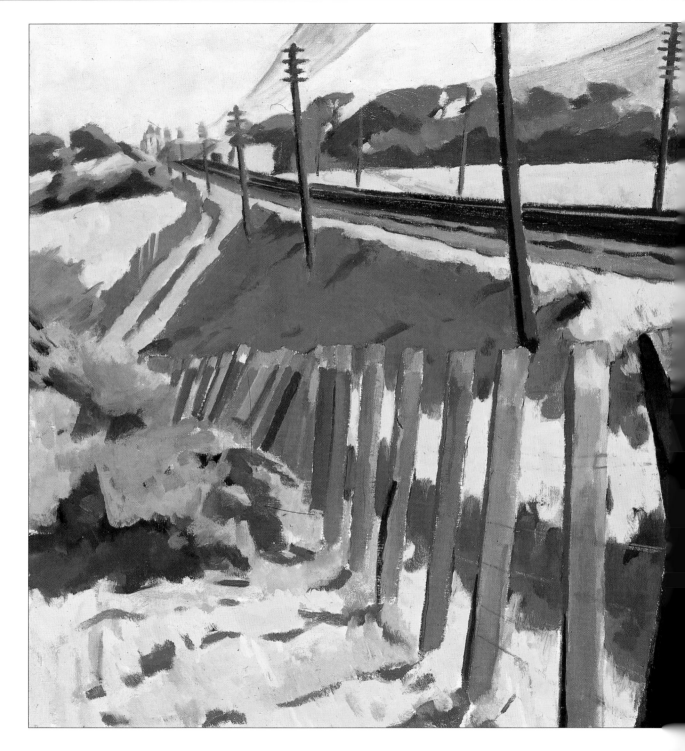

RAILWAY EMBANKMENT

Leech, as his friend Alan Denson noted, had a 'quietly observant manner', an assertion which is borne out by this picture. Here, despite the apparent stillness of the scene, the absence of people, grazing animals, or even of a train itself, the emphasis is on movement, speed, communication, attributes which are conveyed with great subtlety. The main thrust, that of the railway track, which runs diagonally across the composition setting up a strong perspective, is complemented by the parallel lines of the telegraph wires as they too recede into the distance, and the upward push of the ever smaller telegraph poles. But these artificial lines of direction, forced upon a compliant landscape, contrast with that of the rambling fence to the left of the track which takes its course from the lie of the land, and thus brings a rustic and human quality to the scene. The strong sunlight which falls upon the landscape softens the imagery, especially that of the 'iron way', and places the picture squarely within the ambit of Leech's *œuvre. Railway Embankment* is one of his most powerful works.

c. 1938
OIL ON CANVAS (60.2 x 73.2 CM / 24 x 28³/₄ IN.)
ULSTER MUSEUM, BELFAST

Sean Keating

Sean Keating grew up in Limerick. He was educated at the Technical College there but in 1911 won a scholarship to the Metropolitan School of Art, Dublin, where he came under the spell of Sir William Orpen. His subsequent adulation for Orpen was to remain with him for the rest of his career. In about 1913 or 1914 he paid the first of many visits to the Aran Islands, becoming at once entranced with the life there. In time, the rugged character of the western Gael and the equally rugged landscape which he inhabited were idolized by Keating, so much so that by the 1920s and 1930s he was recognized as the leader of the so-called 'national' school of painting. In 1915 he succeeded James Sleator in London as Orpen's studio assistant, but returned to Ireland the following year to teach at the Metropolitan School. In 1923 Keating was elected a full member of the Royal Hibernian Academy and he became president in 1950 in succession to Sleator.

Keating held his first one-man exhibition, in Dublin, in 1921. Thereafter he was represented at all the important exhibitions of Irish art of his time, including the seminal show held in Brussels in 1930. Also in 1930 he held his first exhibition in the United States, in New York. In 1938 he did murals for the Irish pavilion at the New York World's Fair and a year later was awarded first prize in an international competition for *The Race of the Gael*, a picture which extolled the characteristics of the Aran Islanders. Always strongly patriotic, as the leading painter of 'Irish' Ireland Keating expressed the mood, the hopes and aspirations of the new Free State, founded in 1922, with *Men of the West* (1915-16), *An Aran Fisherman and his Wife* (c. 1920s), and *Half Flood* (c. 1930s), the latter two compositions celebrating the 'traditional virtues' of Irish life. Keating was also highly regarded as a portrait painter and he painted many who were prominent in public life. During the 1940s and 1950s he executed a number of religious commissions for churches throughout Ireland.

Throughout his life Keating remained an implacable critic of modern art. 'Art is skill', he stated as late as 1965, 'modern art will go down the drain'. This attitude no doubt stemmed in part from his training under Orpen, but may also have been influenced by his romanticism of the West. To Keating, modern art had upset the development of an artistic tradition based on skill and craftsmanship which he saw as having been handed down like a torch from generation to generation.

THE LIMERICK GIRL
c. 1938-42
OIL ON CANVAS (90 x 74.5 CM / 35¹/₂ x 29¹/₂ IN.) PRIVATE COLLECTION

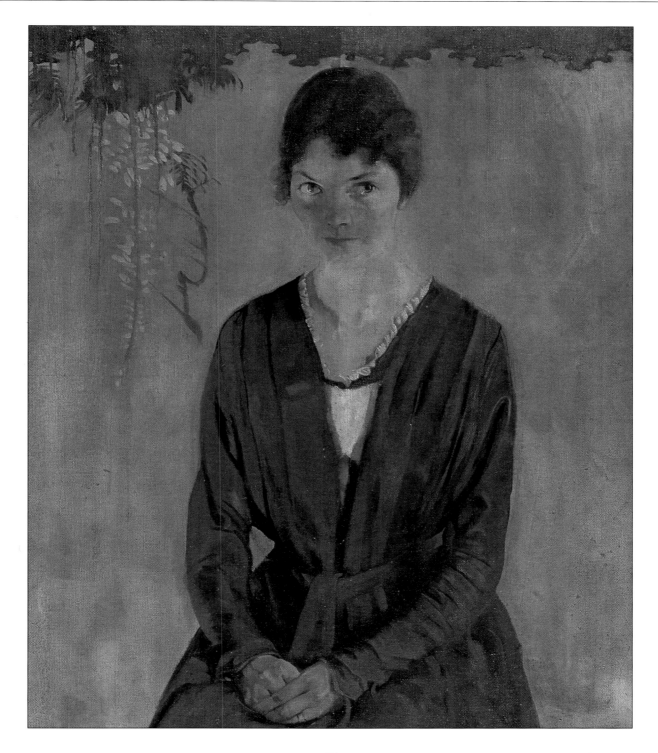

NIGHT'S CANDLES ARE BURNT OUT

This is one of a series of paintings done by Keating for the Electricity Supply Board to mark the construction of the hydro-electric scheme on the river Shannon at Ardnacrusha in County Limerick. The object of the scheme, the first major undertaking of the fledgling Irish Free State, was to make electricity available nationwide. Work at Ardnacrusha began in 1925 and was completed in 1929. Keating's picture therefore symbolizes that dawn of a new Ireland, which was the overall subject of the whole series of works.

Keating had made his reputation with *The Men of the West* (1915-16), in essence a romantic study in fortitude. Thereafter and until 1922, in compositions such as *On the Run, War of Independence* (1921) or *The Men of the South* (1922), he was the unofficial painter of the times. Speaking of compositions such as these Liam Gogan commented perceptively years later: '... if his men bear rifles, one notices these less than the intensity of thought of those that bear them'. With the coming of more settled times Keating turned his attention to the creation of a so-called 'national' school of painting, depicting subjects which were considered to be distinctly Irish and which represented the direction in which many believed the new state should develop. The commission from the Electricity Supply Board thus fitted his aspirations perfectly.

Night's Candles are Burnt Out is an allegorical picture. Speaking of it in 1929, when it was exhibited at the Royal Academy, London, Keating said that it represented the future, symbolized by the coming of electricity for all, and the death of the 'stage' Irishman, represented by the group of figures to the left of the composition and the corpse seen hanging from a power standard. To the right, a group of engineers build the new State and a mother and her son observe their coming inheritance. In the centre the dominant figure of the entrepreneur, with his portfolio of plans, stares contemptuously at the gunman who personifies the Ireland which is passing away. The composition is rhetorical and is imbued with a feeling of dynamic energy.

In all Keating made more that twenty paintings of the Ardnacrusha workings, of which *Night's Candles are Burnt Out* and *The Key Men* (1928-9, Institute of Engineers of Ireland) are the most important, the others being more concerned with the transformation of the landscape than with the immensity of the socio-economic issues involved in the scheme.

1928-9
OIL ON BOARD (99.1 x 104.1 CM / 39 x 41 IN.)
OLDHAM ART GALLERY

SLAN LEAT A ATHAIR/ GOODBYE, FATHER

From the mid-1920s in Ireland the main priority of many artists was the creation of a distinctly Irish, or a 'national', school of painting. In his review of the 1924 Royal Hibernian Academy exhibition, for example, George Russell (Æ), who had been advocating the development of a national school since the late 1890s, commented that there was still no such tradition in the visual arts in Ireland. The general impression of the exhibition, he said, was of 'art without national roots'. The problem, however, was to decide and agree on what would constitute a national art form. To Russell the term meant one which somehow would distil and express the national essence, while most others took it to refer almost exclusively to themes and subjects which laid emphasis on life in the West of Ireland. Reviewing the 1932 Academy, for example, the *Irish Times* critic wrote: 'Unfortunately, the show is less than ever representative of national art. If it were not for Mr Sean Keating's pictures there would be hardly any specimens of the "national" group – the only group that really matters in Ireland at present'.

Goodbye, Father aptly describes the sort of themes which these critics sought. Painted in the Aran Islands, where Keating had first gone as a young man and to which he returned regularly, we see the departure of a priest for the mainland. For Keating the rugged, unpretentious lifestyle of the Aran islanders, combined with what he termed their 'charming gentle manners' and the 'sonorous musical cadences of spoken Irish' represented the qualities that post-independent Ireland should strive for. 'All these things', he wrote, 'decided me that ... [Aran] was where I wished to live and work'.

In concept and execution *Goodbye, Father* is close to the kind of Social Realism which developed in Russia and elsewhere in the 1920s and 1930s. But its frankness, even monumentality, of expression was new to Ireland, as Liam Gogan noted of Keating's work in general: 'His canvases re-create humanity ... his men are real, as are their thoughts and acts ... as real as their curraghs and the violent Atlantic seas which cast them hither and thither'. Sir John Lavery was another admirer of Keating, commenting around this time that he was 'unfettered by any worn-out tradition or convention, a painter of his own times in his own manner'. *Goodbye, Father* was donated to the Ulster Museum in 1941 by the Thomas Haverty Trust, who had acquired it in 1936 from that year's Royal Hibernian Academy exhibition.

1935
OIL ON CANVAS (175.9 x 175 CM / 69 $\frac{1}{4}$ x 69 IN.)
ULSTER MUSEUM, BELFAST

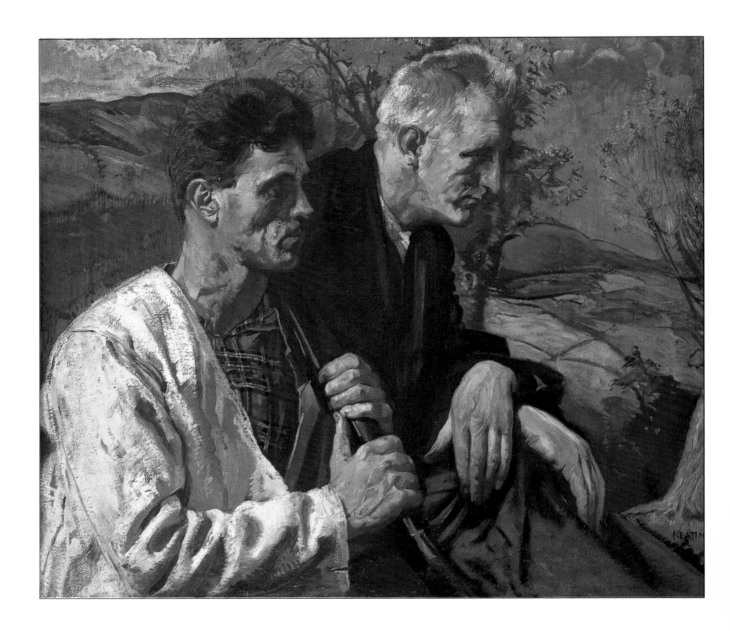

The Race of the Gael

Throughout the 1930s Keating worked for the creation of a distinct Irish School of Art. In 1941 the critic Mairin Allen wrote: 'Mr Keating's art appears to … the man-in-the-Irish-street, as a window through which he can see an idealized view of a Gaelic Ireland, with just that contact with concrete reality in the presentation of detail, which makes even a fantastic folk-tale pass for something like History'. Keating stood as a sort of bulwark of tradition and till the end of his life he despised the ways in which modern art had broken with all that had gone before. Sir William Orpen, under whom he had been a student, was a life-long inspiration to him. 'My life began', he commented years later, 'on the day he [Orpen] looked over my shoulder in the Life Class in the Dublin School of Art at my drawing and said – or rather growled – in his staccato, "That's good! Go on – go on"'. Later, he worked as an assistant to Orpen in London and this experience increased the latter's influence on him. In reality, however, he was too adulatory of Orpen and would have been a stronger painter if he had placed less emphasis on technique *per se*.

Nevertheless, Keating's single-minded approach, his descriptively Realist technique, and ability to represent character 'types'– especially the Gael – was a major achievement. This picture, *The Race of the Gael*, was originally known as *The Irish Race*. In its penetration of rugged character, sense of determination coupled with responsibility and evident physical well-being, Keating has personified what he regarded as the historical essence of the Irish people.

The two figures have an ease of manner and self-sufficiency borne out of honest toil. They are relaxed in their surroundings which, both mountainous and pastoral, clearly provide a bountiful living. To the artist's considerable pleasure, the picture was awarded first prize in 1939 in a worldwide competition organized by the American IBM Corporation and was exhibited that year in the IBM Gallery of Science and Art at the New York World's Fair.

Amongst other well-known works by Keating which eulogise the Gaelic character are *An Aran Fisherman and his Wife* (1916), *The Tipperary Hurler* (1928, both Hugh Lane Municipal Gallery of Modern Art, Dublin), and *Irish Romanesque* (c. 1931). Alas, despite the bravado of these and other pictures, Keating's *Economic Pressure* (c. 1940s, Crawford Gallery, Cork), with its theme of emigration, portrays the true reality of the times for many in Ireland.

c.1938-9
Oil on board (73.6 x 83 cm / 29 x 32³/₄ in. sight)
Private Collection

Mainie Jellett

Mary Harriet (Mainie) Jellett began her studies at the Metropolitan School of Art, Dublin. The training she received there was strictly academic in approach, but in 1917 she went to the Westminster School in London, where her teacher, Walter Sickert, stimulated in her what was to be a life-long interest in modern art. Later, in 1920, with her friend Evie Hone (1894-1955), she moved to Paris to study with the Cubist painter André Lhote, but after a short time both she and Hone went to Albert Gleizes (1881-1953), whose theories of Cubism attracted their attention. Sickert, Lhote and Gleizes were the three big influences on Jellett's career, her 'three revolutions' as she referred to them, but it was the last in particular – with whom she was to work on and off for many years – with his deeply spiritual approach to picture making, who had the lasting influence on her work.

Back in her native Dublin, in 1923 Jellett first exhibited, at the Society of Dublin Painters, a number of abstract canvases which had resulted from her studies with Gleizes, but she met with little critical acclaim. However she (and Hone, who at the time continued to work closely with her) persevered with her explorations – for they truly were such – and by means of exhibitions, lectures, broadcasts and other engagements, by the late 1920s and early '30s, for pictures such as *Homage to Fra Angelico* (1927, private collection), she began to receive guarded recognition for her achievement. By the late 1930s, despite lingering hostility to her work, she was recognized as one of the most innovative Irish painters of her generation, the critic Stephen Rynne, for example, commenting in 1941: 'He who denies art to Miss Jellett denies his own times'.

Jellett's pioneering work with Cubism and abstraction brought her into conflict with the art establishment, principally with the Royal Hibernian Academy, which she regarded as hopelessly introverted and moribund. Thus, with Louis le Brocquy (q.v.), Norah McGuinness (q.v.) and some others, in 1943 she helped to establish the Irish Exhibition of Living Art as an annual venue where the more progressive painters could exhibit their work. Sadly, however, she died a few months after that first exhibition. Only latterly has she been recognised as, in Bruce Arnold's words, simply 'the greatest woman painter [Ireland] has ever produced'.

S E A T E D F E M A L E N U D E
1921-2
OIL ON CANVAS (56.3 x 46.2 CM / 22 x 18 IN.) ULSTER MUSEUM, BELFAST

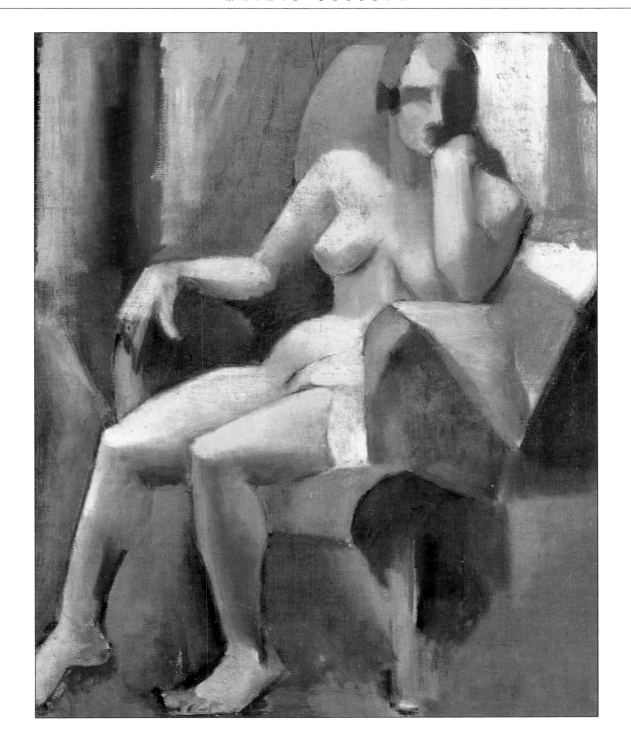

VIRGIN AND CHILD

Having gained a familiarity with the elements of Cubism from André Lhote, in December 1921 Jellett moved to work with another Cubist painter, Albert Gleizes. Thus began the third 'revolution' in her career. The kind of Cubism taught by Lhote was close to the early, or Analytical, Cubism developed by Picasso, Braque and Gris in the years between 1907 and 1914. In those years, having dispensed with perspective (because it was a mere illusion) as a means of organizing relationships within the picture plane, they were concerned primarily with the depiction of forms, which were rendered in a greatly simplified and quasi-geometrical manner and set down often as overlapping shapes and planes and always within a shallow picture-space with little recession. Thus Cubism remained essentially a representational form of painting, although this was a conceptual rather than an optical realism. But as the movement developed a number of painters, including Léger, La Fresnaye, Delaunay, Metzinger and Gleizes, developed what became known as Synthetic Cubism, of which there are many varieties.

Gleizes was one of the early theorists of Cubism, his book *Du Cubisme* (1912), co-authored with Metzinger, being a seminal text. In 1917 he underwent a religious conversion and subsequently endeavoured to interpret the 'laws' of art in terms of spiritual dedication. His subsequent stress on religion had a considerable influence on his pupils, and may in part account for Jellett's quest for the universal, the 'inner principle' over the 'outer appearance', as she put it. Why Jellett was drawn to Gleizes is unknown, but she has said that she wanted to go further in the direction of 'extreme Cubism', by which she would have meant the Synthetic Cubism then evolving.

With Gleizes she developed a highly spiritual art form based on a systematic approach to composition, with shapes superimposed one upon another and sometimes turned about a central axis – a process which she termed 'translation and rotation'. 'Our aim', she wrote, 'was to delve deeply into the inner rhythms and constructions of natural forms to create on their pattern, to make a work of art a natural creation complete in itself … based on the eternal laws of harmony, balance and ordered movement (rhythm)'. The application of this philosophy is evident in the splendid *Virgin and Child*, in which the forms of the figures have been simplified to the point of complete abstraction, although the spiritual relationship between them remains clear and this is heightened by the rhythm and completeness within the composition. Yet for all that one's attention is held by the fine use of colour, sense of texture and surface which make this such a vibrant, harmonious image.

c. 1936
OIL ON CANVAS (61 x 46 CM / 24 x 18 IN.)
PRIVATE COLLECTION

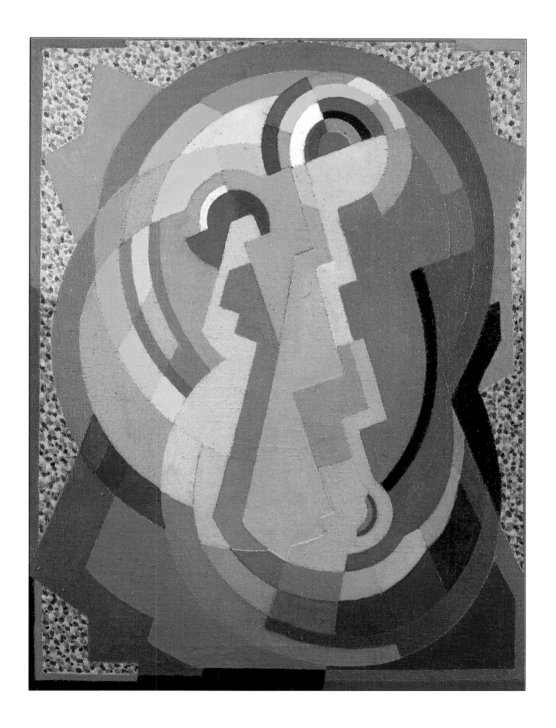

ACHILL HORSES

During the mid and late 1930s a degree of representation returned to Mainie Jellett's painting. The reason for this change is unclear, although by this point, even though she still visited Gleizes from time to time, she was fully matured as a painter in her own right. *Achill Horses* and a few other pictures illustrate the development. In the former composition, which is problematical in many respects, while the horses themselves are recognizable there is no obvious sense of context, narrative or purpose. The foreground is dominated by a group of four horses which prance apparently without cause, while in the background two others seem to stalk some unexplained terrain. The rhythmical shapes prominent in the foreground – which have their source in Jellett's more abstract compositions – lend a quasi-religious aura to the scene and suggest some self-contained world, isolated from the 'real' world beyond. The picture may be read as a metaphor for the times in which it was made, for by the late 1930s, with the war-clouds gathering over Europe, Jellett felt a profound sense of foreboding.

c. 1939
OIL ON CANVAS (61 x 92 CM / 24 x 36 IN.)
NATIONAL GALLERY OF IRELAND, DUBLIN

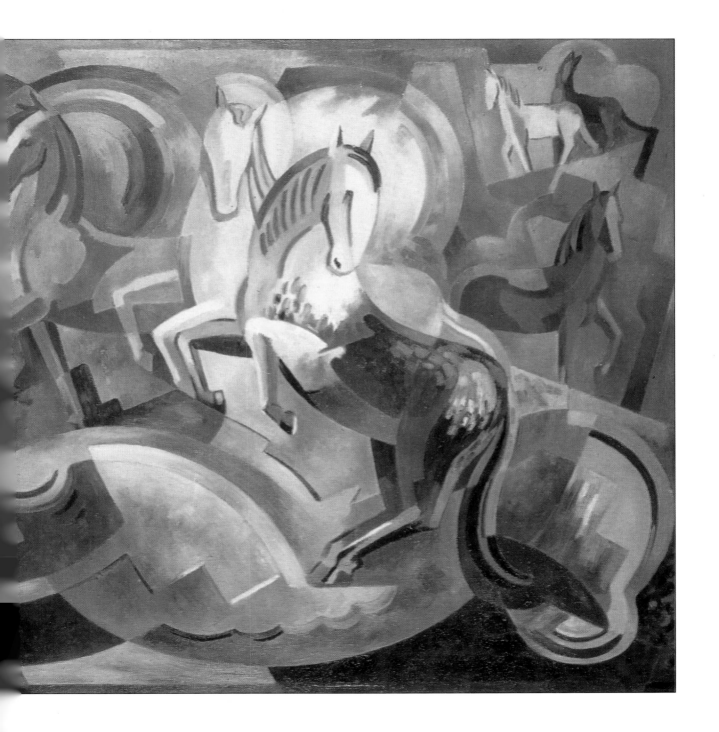

THE NINTH HOUR

In her life, as in her work, Mainie Jellett had a deeply religious conviction, her faith being an informative part of all she did. As the decade of the 1930s progressed she turned more often to her religion as an overt source for her work, seeking to bring to it an increased sense of drama and heightened feeling. 'The surface is my starting point. My aim is to make it live', she had written, but as the thirties wore on she experienced difficulties in coming to terms with the contradiction between the dogmatic approach she inherited from Gleizes and the freer approach of Lhote, which placed emphasis on natural forms drawn from the world around her.

Like Gleizes, throughout the 1920s and early 1930s Jellett had dismissed Analytical Cubism as having failed to develop its inherent possibilities and, in company with Gleizes, she pursued a strand of Synthetic Cubism which increasingly (for Gleizes too) became an arid field. Indeed the very idea of finding so-called 'essentials', 'eternal laws', of making a work of art 'a natural creation complete in itself', seemed more and more implausible, especially during a decade which was moving inevitably towards war. In the long run, these doctrinaire theories and dubious 'laws' of art began to stifle her. But her own intuitive responses retained their vitality and her religion provided the stimulus she sought.

This development in her thinking culminated in the late 1930s in a number of semi-abstract religious paintings of great power and expression. Of these, *The Assumption* (1937), *Descent from the Cross* and *The Ninth Hour*, both 1939 (Hugh Lane Municipal Gallery of Modern Art, Dublin), *The Nativity* (1941, Pyms Gallery, London), *I Have Trodden the Winepress Alone* and *Madonna of Eire*, both 1943 (National Gallery of Ireland), are the most important. *The Ninth Hour* – depicting Christ on the cross surrounded by saints – and *Winepress* compositions are particularly evocative works: in their structural complexity, dramatic use of colour, juxtaposition of light and shade and amplitude they have a power of expression, of pathos, beyond anything else she produced. For these are devotional pictures; they are in large measure autobiographical and summon to mind the very spirit of the times in which they were painted. But above all, in them Jellett regained her own voice; they are an appropriate culmination to her whole *œuvre* and unique expressions of the atmosphere of the Ireland of her day.

1941
OIL ON CANVAS (86.3 x 64.2 CM / 34 x 25 IN.)
HUGH LANE MUNICIPAL GALLERY OF MODERN ART, DUBLIN

Norah McGuinness

D. DUBLIN 1980

Norah McGuinness first began to study painting in 1921, attending the Metropolitan School of Art in Dublin, where her teachers included Patrick Tuohy (1894-1930), Harry Clarke (1889-1931) and Oswald Reeves (1870-1967), three of the most influential teachers in Ireland at the time and from whom she gained a good grounding in draughtsmanship. In 1923 she won a medal for her drawing at the Tailteann Games in Dublin. However in 1924 she moved to the Chelsea Polytechnic in London, and after a few months, at the suggestion of Mainie Jellett, she migrated to André Lhote's atelier in Paris. There she remained for almost two years, working in a rudimentary form of Cubism, for Cubism proper (as she put it) never appealed to her – it and abstraction 'would have been for me empty fields', she told the present author. During her time with Lhote, she came to admire Braque, although she did not emulate his formal structures, but rather took to the more spontaneous approach of Matisse and Vlaminck. Thus colour, mass and tone began to take over from line as the dominant elements in her paintings, and she turned increasingly to watercolour and gouache, which she continued to use into the 1930s.

In 1925 McGuinness married the poet Geoffrey Phibbs, but they separated in 1929, the year in which she went to live in Paris. In 1931, after a few months spent in India, she moved to London, remaining there for six years and exhibiting with the 7&5 Society and the London Group. In 1933 her first one-woman exhibition was held at the Wertheim Gallery – she was a member of Lucy Wertheim's 'Twenties Group', a group of artists all in their twenties – and she held another, at the Zwemmer Gallery, London, the following year. In 1937 she went to New York, and held a one-woman show there, at the Paul Reinhart Gallery, in 1939, the year in which she returned to Ireland to settle in Dublin. She had also begun exhibiting at the Dublin Painters' Gallery, and henceforth showed mainly there and in London.

Besides her painting, McGuinness is an important figure in the development of avant-garde art in Ireland. In 1944 she was elected chairman (and later president) of the Irish Exhibition of Living Art, in which role, as Anne Crookshank notes, she did more for Irish painting 'than any other artist'. In 1950 she represented Ireland with Nano Reid at the Venice Biennale and in 1957 was elected an honorary academician of the Royal Hibernian Academy. A retrospective exhibition of her work was held at Trinity College, Dublin, in 1968.

VILLAGE BY THE SEA
1953
OIL ON CANVAS (68.9 x 91.6 CM / 27 x 36 IN.)
ULSTER MUSEUM, BELFAST

STILL LIFE

Throughout her career Norah McGuinness thought of herself as a landscapist, although she painted many other subjects, including still lifes. Frequently however, as here, she would combine landscape with still-life objects in order to create a setting for the latter, to put them in a meaningful context. Always, her compositional technique remained simple – a few bottles, vases, plants, a chair, as in this picture, dominating the foreground, their arrangement clearly indicating an interior; the landscape providing a background and giving an added conceptual dimension to the subject-matter. Her colours, especially by the late 1950s, are a little strident, our reading of them verging on the abstract rather than the merely descriptive. As Anne Crookshank noted, she would break the areas of her compositions into facets, thus adding to the texture of the whole and emphasizing the flatness of the picture plane.

The overall impression of much of her early work is of a sort of romantic decorativeness which is at times a little melancholy, but always compelling. However, from the 1950s her work, as with *Still Life*, exudes a feeling of joyousness coupled with a sense of quiet, gentle expectation.

c. 1959
OIL ON CANVAS (51 x 76 CM / 20 x 30 IN.)
AIB ART COLLECTION, DUBLIN

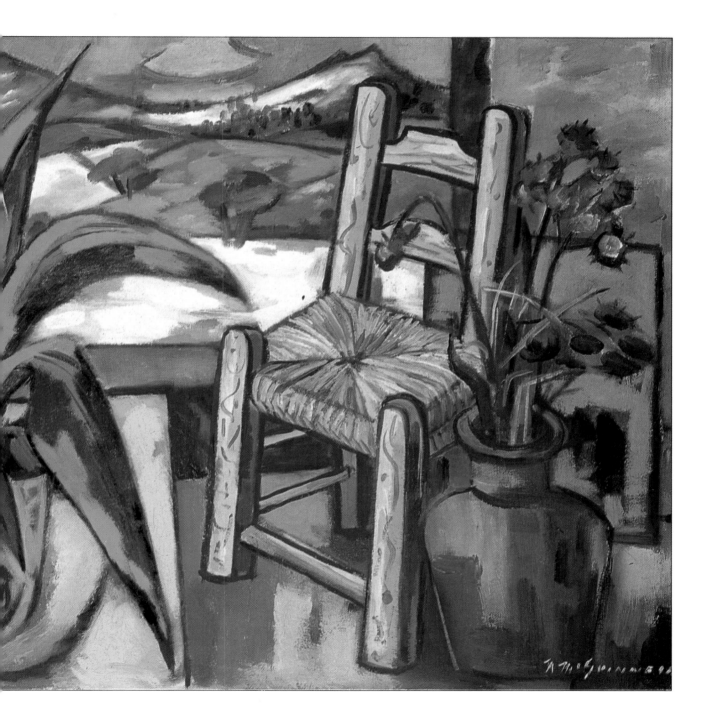

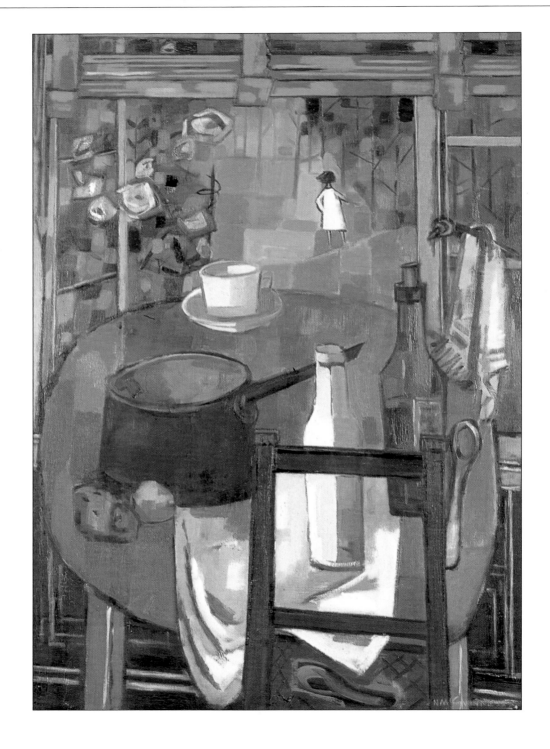

Garden Green

Norah McGuinness was never audaciously avant-garde in her painting yet, as Anne Crookshank has commented, her expressive use of colour and often arbitrary handling of space 'put a gulf' between her and the academic realist tradition in which she was trained. Indeed this 'gulf', which by the early 1940s in Ireland had become an unbridgeable chasm for her and many others, led in 1943 to the establishment of the Irish Exhibition of Living Art, of which McGuinness was the first president. This was a role which she relished and fulfilled with distinction. Indeed it is as much for her encouragement of other artists as for her own painting that her contribution to Irish art is secure. The 'Living Art' exhibitions swept away much of the stuffiness and hierarchical procedures previously endemic in the Irish art scene; in McGuinness' words, it 'cleared the decks' and allowed a new generation to exhibit new ideas.

Yet withal Norah McGuinness never espoused a bold Expressionism or abstraction, both of which forms came to dominate the post-war era in Ireland as elsewhere. Rather, as in *Garden Green*, she adopted a conservative approach which, for a time in the late 1950s and 1960s, drew upon the lessons of Cubism which she had learned with André Lhote thirty years before. Structurally there is here little depth of field to the picture plane. In the foreground a chair and table dominate, but the top of the table has been turned through ninety degrees so as to lie parallel with the picture plane. Some bottles, a pot, and other objects appear to sit on the table, but of course due to its angle of repose they are in fact merely superimposed upon it. This is a typical Cubist technique, and one in which McGuinness may have been influenced by another Irish artist, William Scott (1913-89). The foreground is separated from the background by a window, through which can be seen the garden, with its flowers, a child and some shrubs beyond. But the glory of the composition rests in its deft use of colour, the subtle juxtaposition and harmonization of shades of green, relieved only by a suggestion of pink in one or two of the flowers and the strong light which catches the objects on the table. The picture exemplifies Sean O'Faolain's description of McGuinness' works as 'expressions of painting for living's sake'. 'She is obviously', he said, 'one of those purely instructive artists ... who paint just for the joy of it, not knowing why, being content to know how'.

1962
Oil on canvas (101.6 x 71.1 cm / 40 x 28 in.)
Hugh Lane Municipal Gallery of Modern Art, Dublin

John Luke

John Luke was born in the North Queen's Street area of Belfast. He began working at the York Street Flax Spinning Company, before being apprenticed as a riveter at Workman Clarke's shipyard. In about 1923, while still employed at Clarke's, he started evening classes at Belfast College of Art. Luke thrived at the college. In 1925 he became a full-time student and two years later won the coveted Dunville Scholarship to the Slade School, London. Here he was a student of Henry Tonks, who greatly influenced his development, notably as a draughtsman.

On leaving the Slade in 1930 Luke stayed in London, studying wood engraving briefly with Walter Bayes (1869-1956) at the Westminster School of Art. He also began exhibiting his work and in October 1930 showed *The Entombment* and *Carnival* at the well-known Lefevre Galleries. Reviewing this show, P.G. Konody of the *Daily Mail* thought *Carnival* 'one of the most attractive features of the exhibition'. But as the economic recession of the 1930s deepened Luke returned to Belfast where, apart from a time spent in County Armagh during the Second World War, he remained for the rest of his life.

Luke's manner of painting was painstakingly slow, but precise. Always he worked on just one composition at a time. 'My strength lies in making the most of one job … in sustained thought and effort', he once wrote to his friend John Hewitt. Otherwise, he said, things disintegrated in looseness and frustration for him. The precision of his technique was manifested too in his appearance: erect in stature and always tidy, he was, in Hewitt's words, 'not at all close to the romantic stereotype of the artist'. Besides his work as an artist, Luke taught occasionally at the Belfast College of Art where he was chiefly remembered as a draughtsman of great power. He also produced some sculptures.

Luke held his first one-man exhibition at the Belfast Museum and Art Gallery in 1946 and showed again, with CEMA, Belfast, in 1948; thereafter he exhibited little, although he was a member of the Royal Ulster Academy. In 1950 he was commissioned to paint in the City Hall, Belfast, a mural representing the history of the city, a work which brought his name to a wider audience. Other commissions for murals in prominent city venues followed.

John Luke died in February 1975, a month into his sixty-ninth year. A retrospective exhibition of his work was held at the Ulster Museum in 1978, accompanied by a monograph on his career by John Hewitt. Since his death, his reputation has grown considerably.

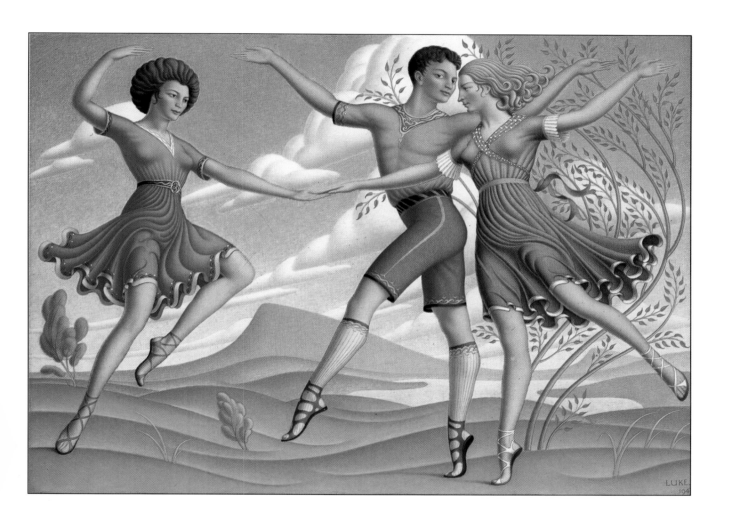

T H E T H R E E D A N C E R S
1945
OIL AND TEMPERA ON COTTON ON BOARD (30.7 x 43 CM / 12 x 17 IN.)
ULSTER MUSEUM, BELFAST

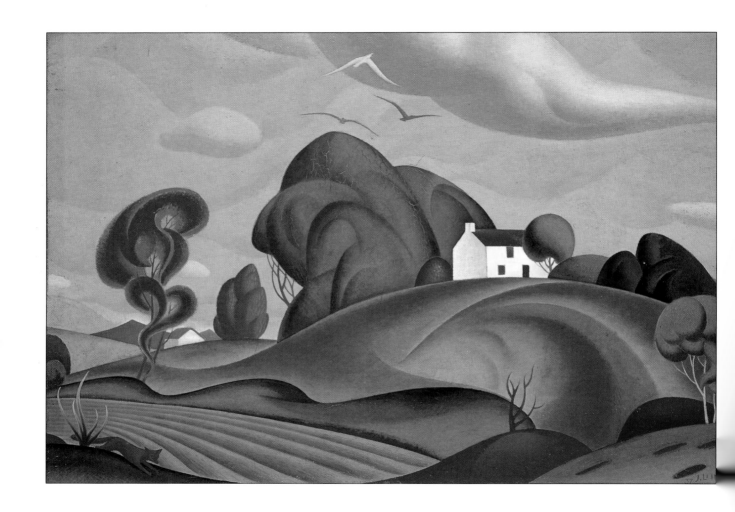

THE FOX

When he was a student at the Belfast College of Art Luke painted landscapes of the city environs executed in a brisk, *plein air* manner derived ultimately from the nineteenth century French painters of the Barbizon School. When he went to the Slade School, however, his style changed radically. There he was a student of Henry Tonks, a surgeon turned artist, who emphasized sound draughtsmanship and taught his pupils to decide what they wanted to say before committing pencil to paper, and only then to set it down, precisely and without hesitation. Luke was inspired by Tonks' instruction and thus began to develop the heavily stylized manner for which he is chiefly remembered. His new style, which evolved slowly during the 1930s, was to emphasize line and rhythm above such things as any gestural brushwork. His paint was usually applied evenly to the surface of the canvas and irregularities such as heavy impasto were absent. In short, he developed a highly cerebral approach to picture making.

From the mid 1930s, in landscapes such as *The Bridge* (1936) – a picture of Shaw's Bridge, near Belfast, – *The Fox* (1937), or *In the Mournes* (1937), and portraits such as that of *Dr Alexander Irvine* (1938), the latter three compositions now being in the Ulster Museum, he created a style which is distinctly his own. In these years, too, he turned to tempera as a medium which, with its stress on line, precise draughtsmanship and the need for the careful meditation of ideas, ideally suited the way in which his technique was developing.

The extreme stylization of shapes and forms seen in *The Fox*, one of Luke's most popular works, is characteristic of the mature state of his highly idiosyncratic manner of painting as it developed in the early 1930s. The influence of Tonks, his teacher at the Slade School, is clearly to be seen in the tight draughtsmanship. Like Tonks, Luke had a liking and a talent for drawing and all of his mature work has a strong linear emphasis. *The Fox* well epitomises this aspect of his work, although the stress on line is in part to do with his use of tempera for the under-painting. Yet despite his stylization, the mood and atmosphere of the landscape are typical of the Ulster scene, as is the simple block-like farmhouse set on a hill and surrounded by trees, with pasture land and tilled ground round about it. Almost part of the curves and sweep of the land, a fox, from which the work takes its name, runs in the lower left-hand corner.

1937
OIL WITH TEMPERA BASE ON PANEL (38 x 54 CM / 15 x 21 IN.)
ULSTER MUSEUM, BELFAST

THE ROAD
TO THE WEST

Although he was not primarily a landscapist, *The Road to the West* shows John Luke at the height of his powers in that genre.

The picture was commissioned by a friend of the artist, John Hewitt, the Ulster poet and Director of Art at the Belfast Museum and Art Gallery, in 1944 to celebrate his tenth wedding anniversary. The composition was based on a drawing made a decade earlier, in 1935, of Slievemore, the mountain which dominates the landscape of Achill Island in the extreme West of Ireland. The title, given to the picture in retrospect by Hewitt, but with the artist's agreement, appropriately conjures up the romance of the West which has been so important a part of the popular perception of the area.

Luke's highly stylized treatment of the landscape contrasts with the more evocative and atmospheric renderings of the same area from the hands of his contemporaries such as Paul Henry, J.H. Craig (1878-1944) or Frank McKelvey (1895-1974). In a generous gesture, Hewitt left the painting to the Ulster Museum upon his death in 1987.

1944
OIL AND TEMPERA ON COTTON ON BOARD
(37 x 63 CM / 14¹/₂ X 25 IN.)
ULSTER MUSEUM, BELFAST

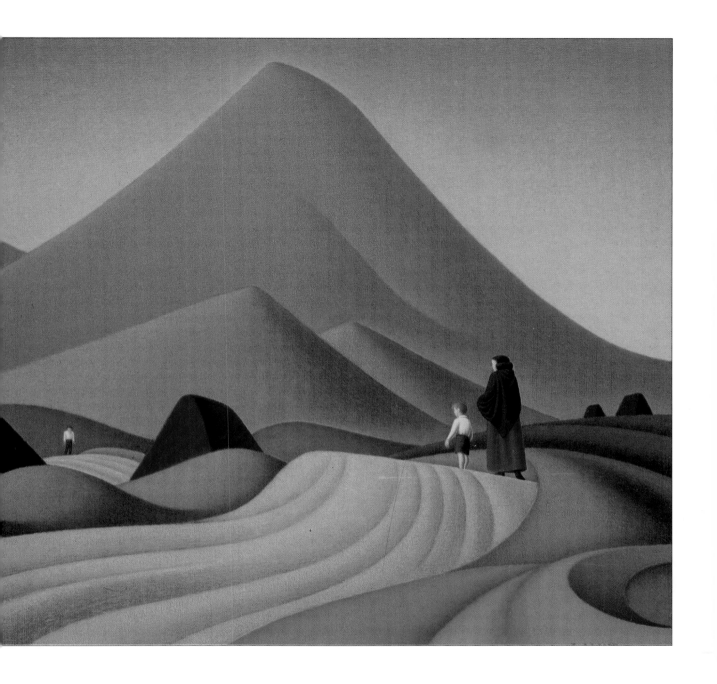

Colin Middleton

Colin Middleton was the son of Charles Middleton (1878-1935), a linen damask designer from Manchester who set up in business in Belfast in 1899. On leaving school he was apprenticed to his father's firm, though at the same time he attended classes at the Belfast College of Art. On a visit to London in 1928 he first encountered the work of Van Gogh and a year later, in Belgium with his father, he was impressed by pictures by the Flemish old masters and by the Expressionist James Ensor. During the thirties he came to admire the English avant-garde painters Paul Nash, Tristram Hillier and Edward Wadsworth and, too, the Surrealist Salvador Dali. When his father died, in 1935, the responsibility for running the business fell to him. That same year he married an art teacher, Maye McLain, but she died just four years later.

During the 1930s in Belfast, Middleton became friendly with John Hewitt, who in turn introduced him to contemporaries such as John Luke and others. Together they would discuss art theories, technique and the philosophy and psychology of art: Middleton was primarily interested in ideas, an approach that shaped his whole career. In 1943 Hewitt gave him a one-man exhibition at the Belfast Museum and Art Gallery, a great accolade for such a young artist.

In 1945 Middleton married Kathleen Giddens, and two years later, having given up his linen business, he and his wife joined Middleton Murray's socialist community in England. But disillusionment set in and the pair were ultimately to return to Ulster. In 1948 he joined the Waddington Gallery in Dublin under contract and so launched upon a career as a full-time painter. In 1957, however, Waddington moved his gallery to London and, lacking the support of a dealer, Middleton turned to teaching, taking jobs at the Belfast College of Art, at Coleraine Technical School and, in the 1960s, at Friends' School, Lisburn. In 1969 he was awarded an MBE and in 1972 he was given an honorary MA degree by The Queen's University, Belfast.

By 1970 Middleton had given up teaching to paint full-time and in 1972 he and his wife took a six-months holiday to visit relatives in Western Australia and in Spain. The trip proved to be exceptionally stimulating and led to the so-called *Swan River* and *Wilderness* series and the *Barcelona Sonnet*.

Middleton's last years, which were very fruitful, were spent absorbed in painting at his home in Bangor, County Down.

HEAD
1938
OIL ON BOARD (30 x 13.5 CM / 12 x 5¹/₂ IN.) ULSTER MUSEUM, BELFAST

THINKING OF ANTWERP

With the death of his first wife in 1939 and the outbreak of war later that same year, Middleton felt acutely pessimistic about the future. The later German bombing of Belfast in 1941, too, had a profound effect on him. As John Hewitt noted, these circumstances gave to his paintings a 'grief-laden troubled strength' which found expression in Surrealism. *Thinking of Antwerp* is one of a small group of pictures, others include *The Discovery* and *The Homecoming*, which were done in the aftermath of those events. In each the predominant colour is red, which seems to symbolize the cataclysmic threat of the times. Indeed in 1943, in notes for his exhibition at the Belfast Museum and Art Gallery, he wrote that he saw humanity's greatest problem as one of survival. He also commented that he was concerned solely with 'individual expression', and this perhaps is the key to understanding his *œuvre* and its eclecticism. In much of his painting, especially that of the war-years, he wrestled with inner tensions and conflicts, probing a sort of spiritual osmosis from the sub-conscious to the conscious. And thirty years later he commented that throughout his career he had been concerned with 'tension … repressed anxiety … all the things that build up and push in on the emotional side'.

Thinking of Antwerp is in part autobiographical. Middleton's mother was of Belgian ancestry and of course he had visited Belgium with his father in 1929. Belgium too had been an early victim of aggression in both world wars and something of a lost haven comes across in the imagery here. The scene is the interior of a café, with a man seated in the background reading a paper, a bar stool and counter behind him, while on the right a woman is seated at another table. The table in the foreground may have been that of the artist. The female figure – a waitress – which dominates the foreground symbolizes fertility and the unquenchable hope of the human spirit. 'What gives my work continuity', commented Middleton in the 1960s, 'is the constancy of the female archetype … the mother figure [as a] communicating vessel'.

Technically, with its flattening of the picture-plane and emphasis on simplified geometrical shapes, this picture owes much to Cubism, although the treatment of the imagery is indebted to Surrealism. In essence, *Thinking of Antwerp* encapsulates humanity's plight at the time. The critic Edward Sheehy commented that Middleton's painting, from being 'imaginative and remote', is 'passionately human with a sustained emotional grandeur'.

1942
OIL ON BOARD (61 x 75 CM / 24 x 29$\frac{1}{2}$ IN.)
ULSTER MUSEUM, BELFAST

COUNTY DOWN FARMHOUSE

This was the last picture painted by Colin Middleton. While his subject-matter in the 1940s and early 1950s was primarily to do with people and with the circumstances of the early years of the Cold War, in the late fifties and sixties he turned increasingly to landscape. In compositions such as the Carnalridge pictures of 1960, the Mourne pictures of the early and mid 1960s, *Sea Wall* (1966, Herbert Art Gallery, Coventry), or *Woven Landscape* (1971), he began to explore the mood and structure of the landscape, treating it – in his own words – in much the same way as the elements work upon it: 'a process of erosion: the polish of wind and rain: the action of sand or the trace of a thorn'. With his trip to Australia in the early 1970s this emphasis changed as he discovered new and strange landscapes; and the influence, which brought Surrealist imagery back to his repertoire, preoccupied him for much of that decade. But in the last years of his life Middleton returned to the landscape *per se* and in a few works, such as *County Down Farmhouse*, we see a fusion of things which had earlier concerned him – form, structure, the landscape as *place* and *experience* – in images which are supremely felt in human terms.

c. 1983
OIL ON CANVAS (45.5 CM x 61 CM / 18 x 24 IN.)
ULSTER MUSEUM, BELFAST

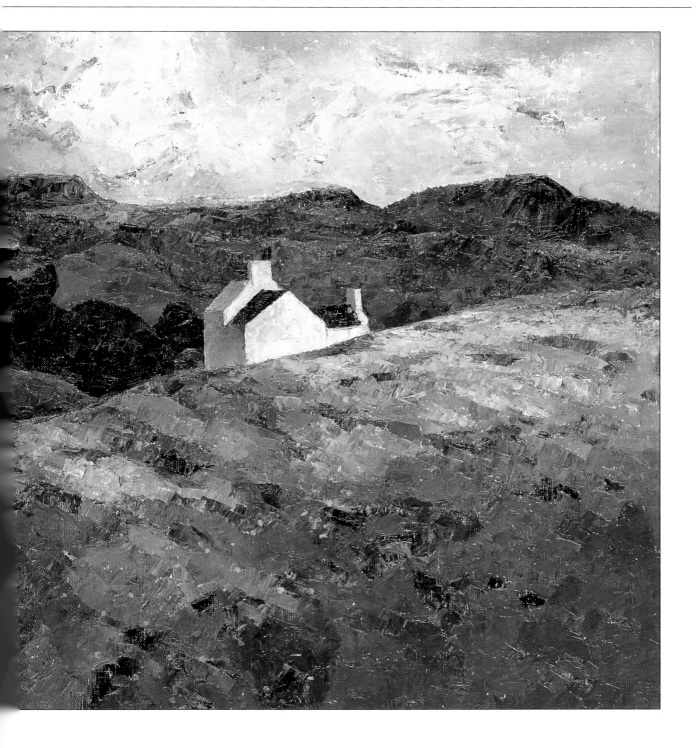

TRAVELLERS MAKING TWIG SIGN
1946
OIL ON BOARD (46 X 54 CM / 18 X 21¹/₄ IN.)
PRIVATE COLLECTION

Louis le Brocquy

Mainly a self-taught painter, Louis le Brocquy studied chemistry for a time at Trinity College, Dublin, before going to work in his family's business, the Greenmount Oil Company. From about 1937 he began painting and he first exhibited at the Royal Hibernian Academy that year. In 1938, the same year in which he married his first wife, Jean Stoney, he gave up his business interests and turned to art full-time, going abroad to study old master paintings in the great European galleries. In 1939 he settled in Menton in the south of France, but with the outbreak of war returned to Ireland the following year. In 1941 he and his wife separated, and were divorced in 1948.

In 1943 he was a founder-member of the Irish Exhibition of Living Art, an event, thereafter held annually, which soon came to represent the best of avant-garde painting in Ireland. Le Brocquy's own work, which in these years developed with great force and purpose, came to exert a considerable influence on Irish painting. With the end of the war, however, in 1946 he left Ireland to live in London, where he began to exhibit with the Gimpel Fils Gallery. In 1956 he represented Ireland at the Venice Biennale, where his composition *The Family* won a major award. That same year saw the beginning of his 'white period', with his so-called 'presences'. In 1958 he married the painter Anne Madden (b. 1932) and shortly afterwards settled at Carros in the south of France, where he and his wife have remained ever since, although they regularly spend a part of each year in Ireland. In 1962 Le Brocquy was awarded an honorary Doctor of Letters degree by the University of Dublin; in 1966 there was a retrospective exhibition of his work at the Municipal Gallery of Modern Art, Dublin, and at the Ulster Museum; and in 1975 he was elected a Chevalier of the Légion d'honneur. During these years Le Brocquy was preoccupied with his well-known 'head' studies, or 'definitions' towards a likeness – or, more precisely, a sense of presence – of various writers and artists, including W.B. Yeats, Beckett, Joyce, Federico García Lorca and Francis Bacon. These works have brought him much acclaim. He has also produced a number of tapestries which have received critical attention, including those for *The Táin* (1970), and *Cúchulain* (1972). In 1985 he was awarded an honorary Doctor of Laws degree at University College, Dublin. In 1996, to mark his eightieth year, Le Brocquy, who has been called Ireland's most important living painter, was honoured by a second retrospective exhibition of his work held at the Irish Museum of Modern Art.

THE SPANISH SHAWL

In art-historical terms this is one of the most seminal works in twentieth-century Irish art. Its rejection by the selection committee of the Royal Hibernian Academy in 1942 was one of the major events which led to the foundation of the Irish Exhibition of Living Art, and hence a wider espousal of Modernism, a year later. To a contemporary eye Le Brocquy's work of the early 1940s may appear largely academic in treatment, but at the time it was seen as unacceptably avant-garde by the art establishment of the Academy.

Le Brocquy had first exhibited at the Royal Hibernian Academy, Dublin, in 1937 and thereafter he showed yearly until 1941. In 1942, however, as with several other young painters, both of the pictures which Le Brocquy submitted were rejected by the selection panel who had determined to resist the encroachment of modernist trends – anathema to the academicians – in the Academy. The rejection coincided with an article by Mainie Jellett (q.v.), then one of Ireland's most advanced painters, published in the journal *Commentary*, in which she was critical of the reactionary stance of the Academy. Jellett's article led to a considerable airing of the topic in the press and, perhaps not surprisingly, feeling that it must take a stand for its principles, the following year the Academy rejected the modernists out of hand. As a result of this action, Le Brocquy, Jellett and a few others decided to establish an alternative arena in Dublin in which to show their work – an almost unheard of action in Ireland at that time – and so the Irish Exhibition of Living Art came into being. It was to have a long and influential future.

The Spanish Shawl, with its emphasis on the isolation of the individual, even in the company of others, encapsulates the enduring subject-matter of Le Brocquy's art. The assurance of concept and delicacy of execution evident in this picture were to become characteristics of his work, and the preponderance of light tones – even white, as here – and gentle tracery of rich colours shows the influence of Edouard Manet, whom Le Brocquy greatly admires. Apart from the figures themselves, the still-life set in the bottom left-hand corner of the composition holds our attention and is exquisite in the subtlety of its colour and brushwork. Writing in 1966 the artist commented that in painting this picture he was exploring 'the analogy between colour and musical cycles or scales', this work being painted 'in the minor key of vermilion … red-orange, yellow, blue'.

1941
OIL ON SILK (98 x 79.5 CM / 38$\frac{1}{2}$ x 31$\frac{1}{4}$ IN.)
PRIVATE COLLECTION

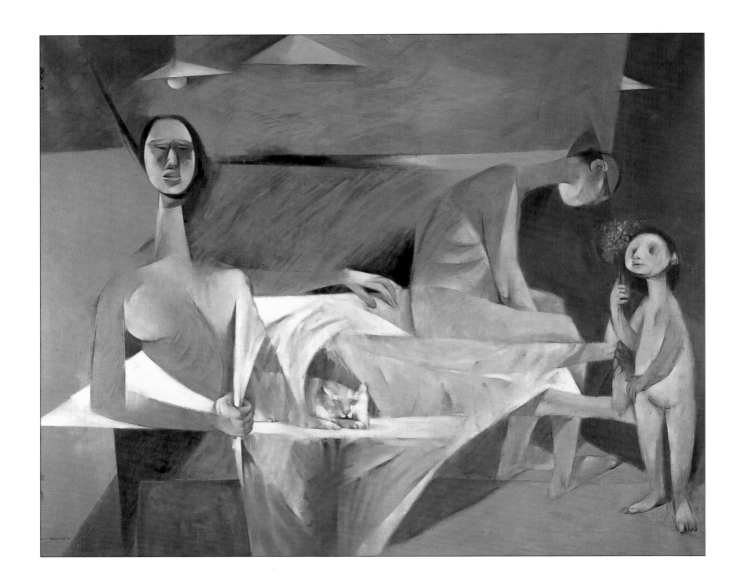

A FAMILY

In the early 1950s Le Brocquy made a number of paintings on the theme of family relationships. *Man Writing* and *Bathers*, both 1951, *Child in a Dark Room* (1953) and *Tired Child* (1954, Ulster Museum), might be mentioned in this context, but *A Family* was the largest and most important of all the works. It marks a watershed between Le Brocquy's early phase, which for a young painter self-taught was one of extraordinary accomplishment, and the beginning of his later work. The subject-matter, the isolation of the individual, remains uppermost, but there is in it a feeling of tragedy which, coming shortly after his 'Travelling People' pictures, with their resonances of the great Famine in Ireland, of the individual as a misfit in organized society, may also reflect the plight of so many in the 'brave new world' of post-Second World War Europe.

Structurally the composition owes much to Cubism. The suggestion of recession in space is limited, the definition of the background is unclear (save for its being an interior) and the extreme simplification of the forms of the three figures, man, wife and child, and of the features are Cubist in origin. The precision of the drawing, on which the emphasis is placed throughout, and delicacy of the painted surface are masterly attributes which, combined with the succinctness of the composition overall, make for a powerfully evocative image. The range of colours is severely limited and this is a foretaste of the 'white' pictures, 'presences' and other related works such as *Recumbent Nude* (1958, Ulster Museum) or *Woman* (1959, Tate Gallery), which Le Brocquy was to paint in later years.

Writing of *The Family*, when it was shown at Le Brocquy's one-man show in London in June 1951, the critic John Berger admired the artist's humility, which, he said, 'distinguishes his work'; and he noted: 'his studies testify to his patience, and [*A Family*] … to his refusal to evade simple but difficult problems by relying on the grandiose cliché'. In December 1951 *A Family* was exhibited in Le Brocquy's exhibition at the Waddington Gallery, Dublin, and was at that time offered as a gift to the Municipal (later Hugh Lane Municipal) Gallery of Modern Art, Dublin, but it was rejected by the gallery's art advisory committee. In 1956 it was included in Le Brocquy's exhibition at the Venice Biennale, where it won a major prize and was acquired by the Nestlé Corporation. Two years later it was included in the prestigious exhibition *50 Ans d'Art Moderne* at Brussels.

1951
OIL ON CANVAS (147 x 185 CM / 58 x 73 IN.)
NESTLÉ ITALIANA SPA, MILAN

JAMES JOYCE STUDY 69

In the mid and late 1950s Le Brocquy painted a number of pictures collectively known as 'presences' – *Recumbent Nude* (1958, Ulster Museum) and *Woman* (1959, Tate Gallery) are good examples. In these, he said, he sought to integrate surface and image in such as way as to form 'a matrix within which the central image may be realised and held'. The idea of a presence, while implicit in all Le Brocquy's work, had its more overt origins in compositions such as *Tired Child* (1954, Ulster Museum) and, more particularly, the tiny head of *Caroline* (1956, private collection). In Alistair Smith's words, the Caroline painting is 'Aristotlean in its premise that the eyes are the gateway to the soul'.

The idea of using only a face to gain insight to the very being of an individual was furthered by a visit Le Brocquy made at about this time to the Musée de l'Homme in Paris, where he saw native Polynesian skulls – 'reconstructed' heads – which similarly penetrated the essence of the subject. These heads also recalled to him the triple-sided Corlech head from the National Museum of Ireland, and the Cúchulain legends which were preoccupied with the head as an image. Other influences were the Swiss sculptor Alberto Giacometti (1901-66) and the painter Francis Bacon (1909-92), both of whom wrestled to depict the unique essence and dignity of the human presence. The idea of ancestry, with its sense of living continuity, also relates to Le Brocquy's 'head' images. Of these pictures, he has written that he tried to evoke 'the conception of earlier lives', to 'reconstruct' appearance – as an archaeologist might seek to do – from the inside outwards.

While the 'head' pictures have their origins in the 'presences' of the early 1950s, the lengthy series of heads, of which the Joyce study is part, date from 1975, although the artist made one or two evocations of Joyce in 1964. The series was originally prompted by a commission to treat W.B. Yeats for a Swedish gallery owner interested in Nobel Prize winners. In these works we read the face as we wish and meditate upon it freely, constructing a likeness for ourselves. In Alistair Smith's words, these images 'deal with the personality stripped of worldly associations', their achievement lying in the 'evocation of a specifically Celtic collective unconscious'. They are indeed the perfect expression of Francis Bacon's comment that Le Brocquy belonged to 'a category of artists who have always existed – obsessed by figuration outside and on the other side of illustration – who are aware of the vast and potent possibilities of inventing ways by which fact and appearance can be reconjugated'.

1977
OIL ON CANVAS (146 x 113.7 CM / 57^1/$_2$ X 45 IN.)
ULSTER MUSEUM, BELFAST

Index of Paintings

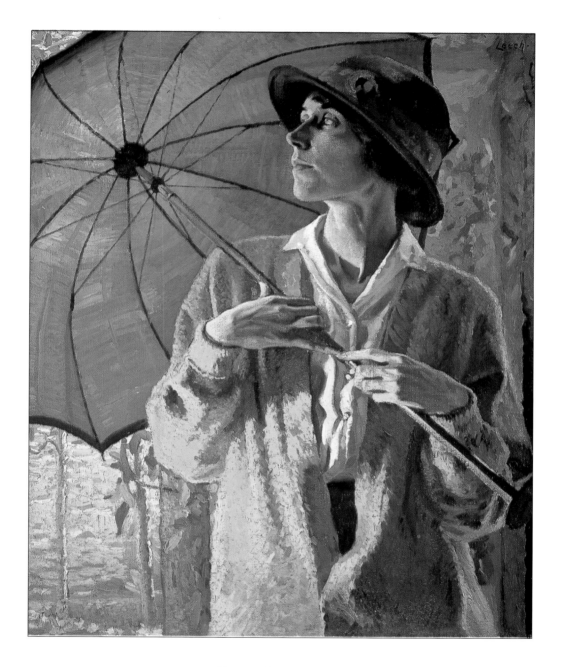

THE SUNSHADE
William John Leech
National Gallery of Ireland, Dublin

Selected Bibliography

GENERAL

Arnold, Bruce: *A Concise History of Irish Art* (London: Thames & Hudson), revised ed. 1971

Boylan, Henry: *A Dictionary of Irish Biography* (Dublin: Gill & Macmillan), 1978

Brown, Terence: *Ireland: A Social and Cultural History 1922-79* (London: Fontana), 1981

Campbell, Julian: *The Irish Impressionists: Irish Artists in France and Belgium 1850-1914* exhibition catalogue (Dublin: National Gallery of Ireland), 1984

Crookshank, Anne and Glin, The Knight of: *The Painters of Ireland c. 1660-1920* (London: Barrie & Jenkins), 1978

Images and Insights exhibition catalogue (Dublin: Hugh Lane Municipal Gallery of Modern Art), 1993

Kennedy, Brian P.: *Irish Painting* (Dublin: Town House), 1993

Kennedy, S.B.: *Irish Art and Modernism 1880-1950* (Belfast: Institute of Irish Studies), 1991

McConkey, Kenneth: *A Free Spirit: Irish Art 1860-1960* (London: Antique Collectors' Club and Pyms Gallery), 1990

Snoddy, Theo: *Dictionary of Irish Artists: 20th Century* (Dublin: Wolfhound Press), 1996

Strickland, W.G.: *A Dictionary of Irish Artists* (Dublin & London: Maunsell), 1913

GRACE HENRY

Allen, Mairin: 'Contemporary Irish Artists XV: Grace Henry', *Father Mathew Record*, vol. 15, November 1942

Kennedy, S.B.: 'Paul Henry: An Irish Portrait', *Irish Arts Review*, Yearbook 1989-90

Cruickshank, James G.: 'Grace Henry', *Irish Arts Review*, Yearbook 1993

PAUL HENRY

Henry, Paul: *An Irish Portrait* (London: Batsford), 1951

Kennedy, S.B.: 'Paul Henry: An Irish Portrait', *Irish Arts Review*, Yearbook 1989-90

MAINIE JELLETT

Arnold, Bruce: *Mainie Jellett and the Modern Movement in Ireland* (New Haven & London: Yale University Press), 1991

MacCarvill, Eileen (ed.) *Mainie Jellett: The Artist's Vision* (Dundalk: Dundalgan Press), 1958

SEAN KEATING

Gogan, Liam: 'Picture Hire Personalities: No. 3, John Keating RHA', *Commentary*, January 1942

Sean Keating and the ESB exhibition catalogue (Dublin), 1987

SIR JOHN LAVERY

Shaw-Sparrow, Walter: *John Lavery and his Work* (London: Kegan Paul, Trench, Trübner & Co.), 1911

Lavery, Sir John: *The Life of a Painter* (London: Cassell), 1940

McConkey, Kenneth: *Sir John Lavery* (Edinburgh: Canongate Press), 1993

WILLIAM JOHN LEECH

Denson, Alan: 'W.J. Leech, RHA: A Great Irish Artist (1881-1968)', *Capuchin Annual*, 1974

Ferran, Denise: *William John Leech* exhibition catalogue (Dublin: National Gallery of Ireland), 1996

LOUIS LE BROCQUY

Chamot, Mary; Farr, Dennis; Butlin, Martin (eds.): *The modern British paintings, drawings and sculpture* Tate Gallery Catalogues (London: Oldbourne Press), 1964

Walker, Dorothy and Russell, John (intro.) *Louis le Brocquy* (Dublin: Ward River Press), 1981

Le Brocquy, Anne Madden: *Louis le Brocquy: A Painter seeing his way* (Dublin: Gill & Macmillan), 1994

Smith, Alistair: *Louis le Brocquy: Paintings 1939-1996* exhibition catalogue (Dublin: Irish Museum of Modern Art), 1996

JOHN LUKE

Hewitt, John: *John Luke (1906-1975)* (Belfast: Arts Council), 1978

NORAH MCGUINNESS

Bodkin, Thomas: 'The Art of Miss Norah McGuinness', *Studio*, September 1925

Crookshank, Anne: *Norah McGuinness* retrospective exhibition catalogue (Trinity College, Dublin), 1968

Hill, Derek: *Norah McGuinness 1903-1980* exhibition catalogue (Dublin: Taylor Galleries), 1982

Walsh, Caroline: 'Caroline Walsh talks to Norah McGuinness', *Irish Times*, 1 May 1976

COLIN MIDDLETON

Sheehy, Edward: 'Colin Middleton: Contemporary Irish Painters (5)', *Envoy*, April 1950

Longley, Michael: 'Colin Middleton', *Dublin Magazine*, vol. 6, Autumn/Winter 1967

Hewitt, John: *Colin Middleton* (Belfast: Arts Council), 1976

SIR WILLIAM ORPEN

Arnold, Bruce: *Orpen: Mirror to an Age* (London: Jonathan Cape), 1981

Keating, Sean: 'William Orpen: A Tribute', *Ireland To-Day*, vol. 2, no. 8, August 1937

Konody, P.G. & Dark, Sidney: *Sir William Orpen: Artist and Man* (London: Seeley Service), 1932

Orpen and the Edwardian Era exhibition catalogue (London: Pyms Gallery), 1987

an Ireland ... imagined: Irish Paintings and Drawing 1860-1960 exhibition catalogue (London: Pyms Gallery), 1993

RODERIC O'CONOR

Benington, Jonathan: *Roderic O'Conor* (Dublin: Irish Academic Press), 1992

Johnston, Roy: *Roderic O'Conor: Vision and Expression* exhibition catalogue (Dublin: Hugh Lane Municipal Gallery of Modern Art), 1996

WALTER OSBORNE

Bodkin, Thomas and Campbell, Julian (intro.): *Four Irish Landscape Painters* (Dublin: Irish Academic Press) 2nd edition, 1987

Sheehy, Jeanne: *Walter Osborne* exhibition catalogue (Dublin: National Gallery of Ireland), 1983

GEORGE RUSSELL

Denson, Alan (ed.) *Letters from Æ* (London: Abelard-Schuman), 1961

Summerfield, Henry: *That Myriad Minded Man: a biography of George William Russell 'Æ' 1867-1935* (Gerrards Cross: Colin Smythe), 1975

JACK B. YEATS

MacGreevy, Thomas: *Jack B. Yeats* (Dublin: Waddington Publications), 1945

Pyle, Hilary: *Jack B. Yeats: a biography* (London: Andre Deutsch), revised ed., 1989

Pyle, Hilary: *Jack B. Yeats: A Catalogue Raisonné* (London: Andre Deutsch), 1992

Acknowledgements

Grateful acknowledgement is made to the following for granting copyright permission to reproduce the paintings in this book:

for Mainie Jellett: Mr M. Purser; for Sean Keating: The Estate of Sean Keating; for Sir John Lavery: Ms J. Donnelly; for William John Leech: Ms B.V. Mitchell; for Louis le Brocquy: the artist; for John Luke: Mrs S. McKee;for Norah McGuinness: Ms R. McGuinness; for Colin Middleton: Mrs K. Middleton; for Sir William Orpen: Miss K. Orpen Casey; for Roderic O'Conor: Sister Olga Dwyer; for George Russell (Æ): Russell & Volkening Inc.; for Jack B. Yeats: Ms A. Yeats

Thanks for reproduction permission is also due to the following for use of their photographs:

The trustees of the galleries and museums listed beside their paintings; Bridgeman Art Library, London, for p. 14 Christie's, Scotland, for pp. 43, 97; Christie's Images, London, for pp. 8, 85; Electricity Supply Board, Ireland, for p. 99; The Gorry Gallery, Dublin, for p. 73; Irish Musuem of Modern Art, Dublin, for p. 130; Dr S.B. Kennedy for pp. 50, 53, 102; Mr. L. Le Brocquy for p. 134; Pyms Gallery, London, for pp. 21, 56; Mr B. Rutledge for p. 133; St Patrick's Church, Belfast, for p.17; Sothebys Transparency Library, London, for p. 83.

The author wishes to acknowledge the assistance of his editor, Fleur Robertson, at Quadrillion Publishing. The editor wishes to thank all who helped her with this book, and in particular Fergal Tobin, Peter Thew and Dee Rennison Kunz of Gill & Macmillan for their kindness.